TWO ZUNI
ARTISTS

Folk Art and Artists Series
Michael Owen Jones
General Editor

Books in this series focus on the work of informally trained or self-taught artists rooted in regional, occupational, ethnic, racial, or gender-specific traditions. Authors explore the influence of artists' experiences and aesthetic values upon the art they create, the process of creation, and the cultural traditions that served as inspiration or personal resource. The wide range of art forms featured in this series reveals the importance of aesthetic expression in our daily lives and gives striking testimony to the richness and vitality of art and tradition in the modern world.

TWO ZUNI ARTISTS

A Tale of
Art and Mystery

Keith Cunningham

University Press of Mississippi Jackson

Copyright © 1998 by University Press
of Mississippi
All rights reserved
Manufactured in Canada

01 00 99 98 4 3 2 1

The paper in this book meets the guidelines for permanence and durability of the Committee on Production Guidelines for Book Longevity of the Council on Library Resources.

Library of Congress Cataloging-in-Publication Data

Cunningham, Keith, 1939–
 Two Zuni artists : a tale of art and mystery /
Keith Cunningham.
 p. cm. — (Folk art and artists series)
Includes bibliographical references.
ISBN 1-57806-062-1 (alk. paper)
1. Zuni art. 2. Zuni artists. 3. Zuni pottery.
4. Fetishes (Ceremonial objects)—New Mexico.
I. Title. II. Series
E99.Z9C85 1998
738′ .092′ 3979—dc21 98–5212
 CIP

British Library Cataloging-in-Publication data
available

CONTENTS

As the twentieth century draws to a close, there is worldwide a growing awareness and appreciation of the excellence and timelessness of Native American art. Pieces are featured in museums in this country and abroad, and an ever-increasing number of juried shows offer prizes and create sales. Retail stores and galleries selling Native American art either exclusively or as part of a larger inventory have opened all across America and in many British and European cities. More and more people are collecting one or several of this art's many forms. These contemporary traditional arts are reaching a steadily expanding audience.

Once, most Native American art was traditional in form, production, and purpose. Art objects and design elements were sacred and meant to evince the supernaturals. Some pieces were part of personal or group ceremonies; others were used in everyday life for cooking, to assure success in the hunt, to bring children, to predict and direct the future, to proclaim and perpetuate a sense of place. This art was not for sale, and was not even to be viewed by those whom the people considered to be outsiders.

Today, many of these forms of Native American art that were once considered sacred have been secularized and are now for sale. Navajo sandpaintings, Hopi kachinas carved of cottonwood, Papago paintings, Pima carved and decorated cooking spoons—as well as Zuni fetishes and pottery—are all contemporary traditional art objects created in the late 1990s. Previously unknown media, such as oil painting, are also being used contemporaneously to re-create traditional sacred or private images for sale. Paintings on canvas have become a major part of this art scene.

This transition by artists from the creation of living art considered to be sacred and spirit-filled to the production of inanimate objects for sale has been neither smooth nor universal. Members of many cultures producing contemporary traditional art feel that new pieces are also spirit-filled. Artists create in the midst of tension and ambivalence.

Objects that are based upon the sacred past and are traditional in content, design, technique, use of media, or combinations of these but are secularized and made for sale in the present are known as "contemporary traditional art." These pieces refer to tradition, but the making of them is market driven. They are becoming increasingly important economically, and the growing number of artists reflects that situation.

Franklin, a contemporary traditional fetish carver, and his mother, Helen, a contemporary traditional potter, have been very much a part of these developments as they have occurred over the years at Zuni. (The names Franklin and Helen, as well as

5

those of members of their family and clan, are pseudonyms, for reasons that will become apparent.)

My wife, Kathy, and I conducted fieldwork with Franklin and Helen for eighteen years, and developed relationships of such closeness that I came to view Helen as my sister and Franklin as my nephew. We first met them in 1978 when Franklin was a four-year-old child, and Helen a young mother and a successful, well-known potter. Through her we met the rest of her extended and clan family: her other children, her sisters and brothers, her father, Max, who was one of the leading political figures of Zuni, and her mother, Kuiceyetsa,who was the descendent of a high priest.

Over the years, we worked at Zuni on projects concerning their health care system and attitudes toward disability, their foodways, legends, music, and funerary and memorial art traditions. We interviewed fifty to a hundred Zunis at least once for these projects. Helen was a valued helper and co-researcher, and we spent increasing amounts of time with her and her family as they became our principal informants on a long series of research projects between 1978 and 1996. She and her family read everything I published about them and enjoyed making in-joke references to my writings.

The idea for the subject of this book came after Helen called us in September of 1993, telling us that her father was going to retire and would be staying home with her mother. Helen said that she was going to open a restaurant and gift shop at Zuni and would resume making pottery which she could sell there. Max had told us years ago about his dream that such a place could provide employment for family members and a market for their art. Kathy and I, who had seen that Max wanted to feel that his family would be taken care of after he was gone, knew that Helen was now trying to put her father's plan into effect. (She once told us of a time when, after she had accomplished something she had set out to do, Max said, "You said you were going to do it, and you did. You're my best son." Helen loved that story.)

Kathy and I knew that both Max and Kuiceyetsa had been seriously ill, and that our time with them was running out. In addition, we were concerned that Max's retirement would deprive the family of income. We hoped that Helen's restaurant would meet the family's financial needs, but we thought it would be helpful if we could design a research project at Zuni and pay the family for working with us. I decided to seek funding so that I could do research for a book about a Zuni tribal artist or group of artists. We drove to Zuni in Oc-

tober of 1993, and talked to Helen. After getting her ideas and support, we planned a proposal.

The folk cultural field survey research method involves several procedures: the conducting of basic library research about the people and topic to be explored; the preparing, testing, and revising of an open-ended questionnaire designed to elicit information from the people about the subject; the conducting, recording, and transcribing of oral interviews; and a tabulation and analysis of the collected material. Kathy and I decided to conduct a folk cultural field survey centered upon art at Zuni which would allow us to interview and to pay Kuiceyetsa and members of her family, most of whom are artists. We would ask them to tell us about art and its place in their lives; we would record their thoughts and use the survey results as background for conducting and recording more extensive interviews and demonstrations with other artists and informants.

We made twelve trips resulting in sixteen recordings of twelve interviews. This book, the story of Franklin and Helen and their art, is based on folk art research that began in April of 1994 and ended in May of 1996.

It is not the book we planned.

It is the book that happened.

The first part of the book presents a historical, linear, and analytical process-product oriented overview of Zuni con-temporary traditional art, including sections on fetish carving and pottery making, and explores the Zuni view of time and the constraining power of culture upon art at Zuni. The second part examines specific experiences, rather than history or theory, in the lives of Zuni artists who are under the influence of this constraining power. Art, artists, feeling, fact, mystery, and context are all aspects of folk art and of this study.

Fieldwork for this book was funded in part by the Northern Arizona University Organized Research Committee, the Arizona Commission on the Arts, and the Holbrook Unified School District, and I thank them. I also thank Tony Marinella, Museum of Northern Arizona Photo Archivist, Richard Pearce-Moses, the Heard Museum Documentary Collections Archivist/Automation Coordinator, Arthur Olivas, Palace of the Governors Museum of New Mexico Photo Archivist, George E. Duck, Maxwell Museum of Anthropology Photo Archivist, and Louise I. Stiver, Curator of Collections, Laboratory of Anthropology Museum of Indian Arts and Culture, Museum of New Mexico. I express my gratitude to Michael Owen Jones and to JoAnne Prichard. As always, I am especially indebted to Kathy.

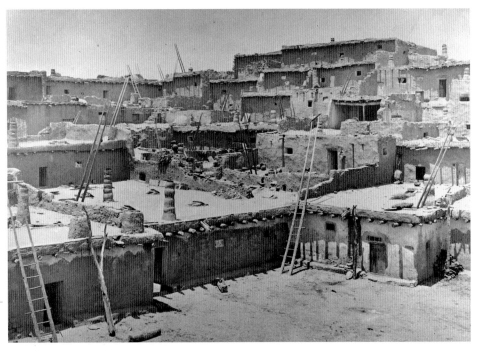

Five-story Zuni pueblo—first American skyscrapers. This 1873 picture is one of the first known photographs of Zuni. (Photo by Timothy O'Sullivan, Selgem Number 61.13.803, Imhof Collection. Courtesy Maxwell Museum of Anthropology.)

How easily things break. The center would not hold. Even at the Middle Place, the Zunis' name for their homeland, the center could not hold. The stories of being followed by police, the mythic conflict between waves of attacking witches and bursts of psychic energy from the grandpas, the fate of a universe whose planets had gotten out of balance and was headed toward destruction unless realigned by Spirit Helpers, the messages from the dead, the eternal conflict between Zuni brothers and Zuni sisters, the pot never made—it was all a mystery of stories and pots and fetishes, and it can only be told as a story of fetishes and pots and mystery.

The story, of course, begins at Zuni. These Native Americans live south of Gallup, New Mexico. The name refers to an ancient people, to their language, and to their present-day village and reservation. Zuni pueblo culture is related in many ways to the other pueblo cultures of New Mexico and Arizona.

As scholars define it, the history of an area or group begins with its first written records. In this sense, Zuni history began when the Spanish explorer Estevan walked into one of the Zuni villages in 1539. It was an inauspicious beginning. Estevan, according to Zuni oral tradition, attempted to seize women and jewelry and was executed. Father Marcos de Niza, the friar who was coleader with Estevan of the small party, fled the scene. He returned the next year accompanied by a large, heavily armed expeditionary force headed by Coronado, who led an assault on Hawikuh, a major village. The one-sided defeat of the Zuni in the face of superior arms was the only battle they fought against European invaders. Coronado was wounded, but he entered the village and dictated a peace.

Having made the conquest, the Spanish discovered that the Zuni had little of interest to their home country. The Spanish used Hawikuh as a military outpost and established a mission there in 1629.

In 1680, after a long and eventful interaction with the Spanish, the Zunis joined other captive pueblo peoples in an uprising. The Pueblo Revolt was a military masterpiece, founded upon a series of alliances among many villages whose inhabitants did not like each other very much but who shared a common enemy. At a predetermined moment, the pueblo people rose as one, overwhelmed the Spanish, and drove them from the Southwest. The Zuni then withdrew to a defensive position on the top of Corn Mountain, a nearby mesa, and lived in this fortified village for nineteen years.

The pueblo victory did not hold. The viceroy of New Spain ordered the reconquest of New Mexico, but he lacked the money necessary to equip and mount an expedition. Diego de Vargas Zapata Luján Ponce de Len y Contreras, a wealthy nobleman and experienced warrior, volunteered

A HOME FOR ART

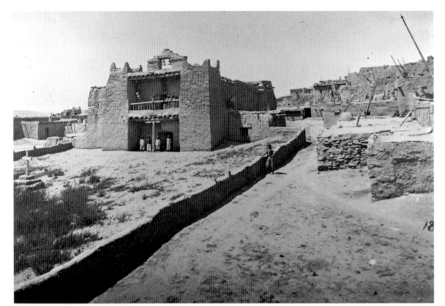

Mission at Zuni, 1873–74. This is another very early photograph of Zuni. (Sel-gem Number 61.13.802. Courtesy Maxwell Museum of Anthropology.)

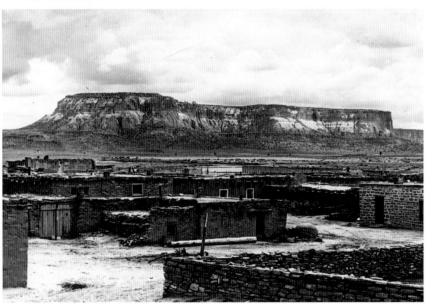

Zuni pueblo, ca. 1925. The mesa in the background is Corn Mountain. (Photo by W. T. Mullarky, Neg. No. 4998. Courtesy Museum of New Mexico.)

to finance and lead a campaign to reconquer the lost area. He was given permission for his plan when he agreed to search for a set of lost mines.

Leading his group through New Mexico in 1692, Vargas discovered that the war alliance which had driven out the Spanish could not abide peace. The villages were no longer united, and the reconquest began. Vargas and his men arrived at the foot of Corn Mountain in November of that year. They dismounted and climbed the long, steep trail to the fortified village high above the abandoned Zuni dwellings. Vargas wrote that he "reclaimed" Zuni. The Zuni came down from the mountain in 1699 and acknowledged Spanish rule. (See Plate 1)

When the Spanish had first appeared, the Zuni were living in several villages; by the time of the Pueblo Revolt, the number had been reduced to four. After the revolt, Hawikuh and all of the other villages but one were abandoned. (See Plate 2) The returning Zunis all settled into one village, Halona, which would become modern Zuni.

In the years following their "discovery" by the Spanish, the Zuni became a part of New Spain, of Mexico, and finally of the United States. The Zuni population has alternately grown and shrunk. The vast majority of the estimated ten thousand Zuni who remain on tribal lands presently live in the one village now called Zuni or in its modern suburb, Black Rock, to the east. There are also four outlying farming cen-

Reservation boundary marker sign.

ters occupied seasonally by some people from the village.

For many reasons, Zuni became one of the most studied groups in the world. In prehistoric times, they had been major traders over a large area of the Southwest, and, later, their ability and willingness to deal with outsiders on a short-term basis made them an attractive destination for outside researchers. Early photographers found Zuni to be an exciting subject. Photographs and travel accounts of Zuni helped make the village one of the most widely known Southwest cultures in the United States.

The ethnologist Frank Hamilton Cushing lived at Zuni from 1879 to 1884; his research published in popular magazines drew much attention to Zuni. He arranged for a group from Zuni and Hopi to tour

11

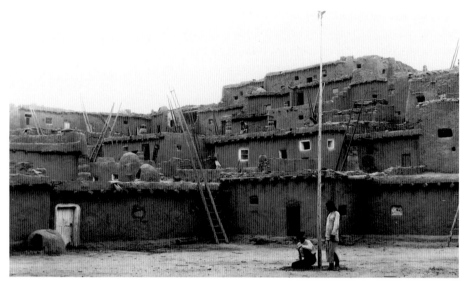

Scalp ceremony, Zuni pueblo, ca. 1885. Frank Hamilton Cushing is shown kneeling by the pole. (Photo by I. W. Taber, Negative Number 78724. Courtesy Museum of New Mexico.)

the eastern United States in 1882, and their travels became a media event. The four Zuni and one Hopi were received by President Chester A. Arthur and invited to comment upon their experiences in the East. Major news sources of the time followed the trip very closely, and the publicity certainly contributed to the appeal and romance of Zuni.

Professor Franz Boas of Columbia University, one of the most important figures in American anthropology, visited Zuni for a short time in 1920 and recommended it to many of his students as a "field" of research. In 1949, Harvard mounted a challenge to Columbia's dominance in cultural studies and sent researchers to the area in and around Zuni. Every publication raised more questions and increased the level of

interest; Zuni became the place for cross-cultural theorists to go. In addition to Cushing and Boas, almost every major researcher in American cultural studies went to Zuni, among them Matilda Coxe Stevenson, Frederick Hodge, Franz Boas, Elsie Clews Parsons, Alfred Kroeber, Ruth Benedict, Ruth Bunzel, and John Adair. As a result of over a hundred years of this work with the Zuni, much is known about them.

The Zuni village and culture have been recognized as one of the most tightly knit and group-oriented societies in the world. The emphasis there is upon the people, not the person. The Zunis have developed and instituted a complex set of expectations involving cooperation which are an important part of the situational context of their art.

The life of one Zuni who stood out

from the group was chronicled over several decades by anthropologists including Cushing, Benedict, and Bunzel. In the 1890s, so the story goes, a young man named Nick Tumaka was reported to have made scornful boasts against the group. He was accused of witchcraft and strung up by his elbows. He sent his father to Gallup for help, and a company of soldiers was dispatched to rescue him. He then left Zuni.

Later, however, Nick returned and was elected governor by the people of the tribe. All agreed he was highly qualified. Nick spoke English and Zuni, he could read and write—some Zunis say the message he sent to Gallup for help was written on a piece of paper—and he had already had contact with outsiders. The Zunis were perhaps hoping that Nick could save them from the dangers of the outside world, but it is clear that they did not accept or respect him. He was a lonely man, and there were rumors after his death that he died because he had given away Zuni secrets. Even during our visits to Zuni many years later, people told us that Nick had been wrong to bring the army to Zuni, and the army had been wrong to come. "What business was it of theirs?" they said.

Zuni is a tradition-laden culture, with a rich, complex, and pervasive ceremonial life. The Zuni world is filled with traditional art—song, music, dance, and costumed pageantry.

Scholars have claimed for Zuni the distinction of having the most elaborate living tribal costume and mask tradition in North America. This great cycle of sacred ceremony fills the village; there is a ceremony or public event almost every weekend of the year. These are held by the village for the village; outsiders have sometimes been allowed to attend, but recording, picture taking, and even sketching have been forbidden since the 1920s.

Most traditional Zunis who live in the village and many of those who have moved elsewhere are directly involved as performers and as audience in the continuing group process of creation. The Zuni belief is that these group activities make both the temporal and the eternal village function and persevere. The one serves the many.

Zuni time is measured by two ceremonial dance events held in association with the longest and the shortest days of the solar year: Mid-Summer Dance, held near the summer solstice, and Shalako, held near the winter solstice. (The Zuni word "Shalako" refers to the ceremony, to the costumed figures of the dance, and to the spirits they personify.) Both periods of time, from Shalako to Mid-Summer Dance and from Mid-Summer Dance to Shalako, involve major cycles of dances, retreats, and pilgrimages. The dances are long and arduous, and preparation includes practice for dancers and drummers, refurbishing of costumes, bread making and sheep slaugh-

13

tering, learning of traditional prayers and responses, and the building of a set of traditional houses for the performances.

As the announced day of Shalako draws near, the air crackles with excitement. Those who live in the village and, when it is permitted, visitors gather in a huge crowd along the road beside the Zuni River and the bridge that the Shalako procession will cross. People visit and talk with each other until, suddenly, there is a communal intake of breath and then silence as the dance figures appear at the top of a hill in the distance, silhouetted against the setting sun.

After some time has passed, from the west and across the bridge come the *Ko-ko*, the Council of the Gods, led by the Fire God personated by a Zuni boy. His body is painted black with circles of red, yellow, blue, and white—the colors of the sun, according to Zuni iconography. He carries a burning cedar torch in his hand and wears a bag of seeds over his shoulder.

The Rain God of the North follows. Dressed in white buckskin and bedecked with jewelry, he wears a mask of black and white stripes with a long curved horn on its right side and black hair on its top.

Others of the Council of the Gods and their attendants come as well. In the west appear also the Shalako (the messengers of the gods) carrying bird-like masks with clacking bills above nine-foot-tall conical costumes made of painted buckskin stretched over willow-wood frames.

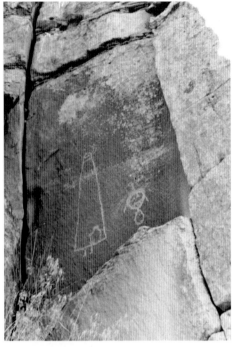

Zuni Shalako and turkey petroglyphs.

After private ceremonies, each of the Shalako goes to the house that has been specially built for him. In the enormous empty space at the center of the house, accompanied by others of the Council of the Gods and by the sacred clowns wearing grotesque mud-daubed masks, the Shalako dance. Through the night, making an unearthly cooing, they dance for the people and for the people's welfare.

The public dances at the houses end near dawn. To the prayer of dance is added the prayer of language as the messengers and their entourages retire for private ceremonies. In the early afternoon, they

14

reappear, cross back over the Zuni River, and go to a large, empty field. The tall conical figures trace intricate patterns as they run gracefully from point to point in an ancient, dramatic dance, planting prayer sticks. The dance reflects the village and the people's state of grace and foreshadows and reveals fates to come.

After the Shalako run for the people, outsiders leave the village. Dancing continues for four more days after the public ceremonies, and then new dancers are chosen for the next year. The cycle ends and begins. After Shalako, Zuni dances toward Shalako.

Zuni is a performing artists' colony. Most of the men of the village are skilled, trained dancers, singers, and musicians who perform in the great cycle of ceremonial dances. The women, too, play parts in social dances, in secular dance and song performances, and in Muddyhead Payday, a yearly ritual in which they dress in traditional costume and present gifts to their clansman who played the part of a sacred clown in the long cycle of ceremonies. Women also perform indirectly as makers of the hundreds of loaves of bread and bottomless bowls of stew and pots of coffee that support and underpin all ceremonies at Zuni. (See Plate 3)

There are also Zuni artists who excel at pottery, stone carving, and interior design. Several of these Zunis have been "discovered" by Anglo-Americans and Europeans

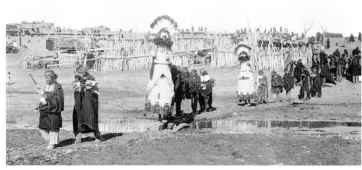

Shalako dance, Zuni pueblo, November 1897. The Shalako figures and their attendants were headed south across the river after the final ceremony of the season. (Photo by Ben Wittick, Negative Number 16443. Courtesy Museum of New Mexico.)

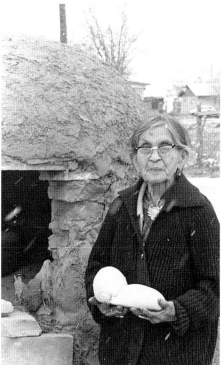

Zuni woman holding a loaf of bread as a snowstorm moves in from Corn Mountain.

15

and have become internationally known and honored, but almost every man and woman of Zuni is or has been an artist practicing the creation of handmade objects: pottery, fetish carving, jewelry making, costume design and creation, dance, music, song, rock art, and, in the twentieth century, oil painting and watercolors. At Zuni, art is life. It is estimated that 30 to 50 percent of Zuni income is generated by the production and sale of art, and someone in almost every family earns some money in this way, in addition to whatever other income they may have. The village and the people's lives are filled with and illuminated by their art.

There is a collective nature to Zuni art and artists as there is to all things Zuni. Far from being the recluse individualist of Euro-American stereotypes, the Zuni artist is Everyman, and members of families often work together to produce their art. Until very recently, art was always seen as a family, rather than an individual, activity. Now there is some tension between artists who are part of a family tradition and those who are not. The Zuni art produced by families and by individuals is both traditional and communal.

Fetish carving and pottery making continue to exist as sacred and family arts, with the objects being made for ritual use. New markets have resulted in the production of pieces which are based upon sacred forms but are unsanctified and are for sale to outsiders. By producing for this market, artists can generate income that supports them and their families. Here, too, the one serves the many.

Zuni artists, however, live in the shadow of a terrible double-edged sword. If they are "discovered" by outside collectors and dealers, they may be viewed by their community as creators of individualistic and distinctive art rather than of traditional art, as being too concerned with the material world and the making of money, as having too much contact with outsiders. If the community believes that an artist is having too much individual success and developing a reputation—"standing out"—there will be accusations of witchcraft. These accusations serve within the tradition as a way of making the one become again a part of the many. The first duty of a successful artist is to get treatment and forgiveness from a medicine man and to seek reintegration into the community. If an artist fails to do that, or if success is too great or long-term, civil, social, economic, or cultural sanctions follow.

Interior design is a basic folk art tradition in most groups. How we arrange and decorate our private spaces, choosing certain objects and displaying them in particular ways, is a means of telling others and ourselves the reassuring story of who we are and to what culture we belong. The nature of Zuni communal art is embodied by

interior design; Zuni homes have always been filled with art in the form of family possessions. Families today own much more than their ancestors did, but the principle is the same. Zuni interior design, like Zuni ceremonial life, is complex, rich, full, and culture affirming.

I have known many such homes. There are the crackling sounds and spicy odors of burning cedar and the touch of two waves of radiant heat: one from the modern airtight wood-burning stove in the living room and one from the original classic pueblo high corner fireplace in the adjoining kitchen. (Plate 4) The walls of the front room and of the kitchen, and the many shelves there and between the rooms, are covered with objects: mounted deer heads, antlers draped with turquoise necklaces, oil or acrylic paintings on canvas, wood, or stone, carved fetishes, pottery, photographs of family members, ritual drumsticks and lances, weavings, and pieces of jewelry. (Plate 5) On the floors are colorful rugs spread over many layers of patterned linoleum laid over tightly packed dirt. The furniture is covered with more weavings, afghans, and throws. The room glows with color and creativity. Most of the paintings are based upon Native American ceremonies, sacred dances, or stylized design traditions. The paintings and other objects have been made by the people who live here, members of their extended family,

clan relatives, or friends. The room is a metaphor as well as a place.

Years ago a psychiatrist did research among the Zuni and Navajo using a projective test. She had the people being interviewed describe a set of pictures of emotionally loaded situations. Like most Anglo-Americans, many of the Navajos saw the pictures in terms of an overall situation. The Zuni subjects noted every object and empty space in the pictures, describing each in precise detail. This principle of seeing the many as the sum of individual parts, yet also a gestalt, is the essence of Zuni worldview and is reflected in the interior design of their homes. A room is so covered with art objects that it becomes one itself.

Zuni art is grounded in a nonlinear view of time; prehistoric pots stand next to contemporary pieces. The past is a physical presence.

Starting library research on Zuni culture, we read that Anglo-Americans see time as linear while Zunis view it as a spiral or circle. It seemed to us that a circle or spiral was just a curved line—not so different, surely. Over the years we have realized that the Zuni idea of time is much more involved. A culture's view of time is bound up with its

Zuni pueblo home interior, ca. 1890. (Photo by Ben Wittick, Negative Number 5047. Courtesy Museum of New Mexico.)

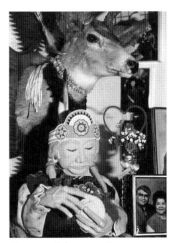

Corner of clan sister's front room.

17

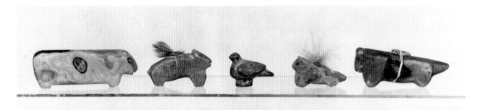

Hunting fetishes from Zuni pueblo. The set probably dates from the mid to late 1920s. (Photo by W. T. Mullarky, Negative Number 43172. Courtesy Museum of New Mexico.)

concept of change. Cultures in which the rights of the individual are paramount see change in every nuance of difference and have a particular fear of the change that is death. Because the Zunis value the group above the individual, they see continuities rather than change and all moments in one.

One day several years ago, Kathy and Helen were alone together for the first time, such moments being rare at Zuni. They sat and talked about their shared concerns for Helen's family. At one point, thinking of the conversation, Kathy said, "How did we get here?"

Helen's answer went in a different direction. "We have always been here," she said. "Two women sitting in a house on the banks of the Zuni River discussing their family."

Fetishes and Carvers

Many cultures, including Zuni, believe that every thing—rock, tree, bird, human, mountain—has a spirit in addition to its physical properties. Members of such cul-

tures find or carve figures of animals and supernatural beings—fetishes—believing them to embody spirit and using them for religious purposes. In the Americas, fetishes are pre-Columbian. The people who lived in the Zuni area in the seventh century had pottery and stone fetishes. The Zuni have long made fetishes for other Native American groups as well as for themselves.

Most of the early fetishes were not for sale or display. As recently as the 1940s, fetishes at Zuni were religious objects— some at least four hundred years old—that were not seen by the outside world. These fetishes were used as a part of the everyday, ongoing magic life of the village. Some were encrusted with blood offerings from the kinds of animals they would help hunters kill; others were kept in special pottery jars and fed cornmeal. Many of these fetishes still exist as a hidden part of museum collections or for use in private Zuni ceremonies.

Information about these fetishes and what were believed to be their magic properties was first presented to the American public in Cushing's 1883 book, *Zuni Fetishes.*

18

Cushing was interested in the uses of the fetishes and the Zunis' classification of them rather than in their artistic aspect or their creators. He lovingly retold stories about the fetishes, and he described the sounds and translated the text of the great ceremony held each year in which everyone brought fetishes to a room and blessed them during an all-night ceremony of singing and dancing.

The fetishes Cushing sketched could have been made in prehistoric times or during the 1940s when natural historian Ruth Kirk published her seminal research or even today. Some are natural stones that resemble animals. Some are carved in a traditional or idealized expressive style; others are realistic. All were sacred. In the last half of the twentieth century, however, Zuni art fetishes—carvings designed for sale rather than for ceremony—have become a recognized and accepted contemporary traditional art form. The history of the transition reflects the complex interaction between tradition and market.

From the 1920s through the 1950s, Zuni artists, including Teddy Weahkee, Leekya Deyuse, and Daisy Hooee, produced a number of carved stone statues for C. G. Wallace, a leading trader of the time. The pieces were strikingly representational statues of Indians in appropriate costume, of plants, and of human hands and feet. In the 1950s and 1960s a Zuni art form closely related to fetishes became

popular in the world outside the village and created a market for itself. The form was the fetish necklace made of thousands of tiny carved animal figures strung with alternating beads or pieces of shell, turquoise, or coral. Many carvers made the small, stylized animal figures. The fetish necklace retains some of its popularity in the late 1990s.

Commercial carving became more common in the period from 1960 to 1985. Approximately thirty carvers in the village made fetishes for sale. In the late 1980s the market for Zuni fetishes began to change, and Zuni contemporary art fetishes became very popular. Most of these are small, but some are large, highly polished carvings. Although the majority are animal figures, carvings also exist of supernaturals such as the Olla Maiden, the Zuni guardian of women.

Carvings are made from many kinds of minerals, semiprecious stones, wood, horn, or bone; most have eyes of contrasting material. Buffalo fetishes also have horns of contrasting material, bears often have fish in their mouths, and many figures have arrowheads attached. Fetishes are quite beautiful, relatively inexpensive, and highly collectible. The basic materials and tools for making them are available at many Zuni stores, which also buy and resell the finished fetishes. We found that almost every young Zuni man makes, has made, or is going to make fetishes.

One fetish maker we interviewed was

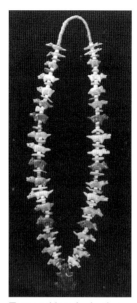

Zuni necklace by Leekya Deyuse. (Photo by Peter Pilles, Photo Number 69.204. Courtesy Museum of Northern Arizona Photo Archive.)

19

Joseph R. Quam, Jr., who was born in 1969. Joseph keeps the fetishes which are for sale in a black velvet-lined tray. For several years when he was first beginning to carve, he worked with wood, making cedar bears with turquoise fishes in their mouths. (Plates 6 and 7) Presently, he works with stone. He spoke articulately about his craft.

I started making fetishes about twelve years ago. I guess I have made thousands of them since I started. I mainly make bears and buffaloes, because those are the ones buyers ask for. The range of prices depends on how much work I put into the fetish and how the shine comes out. The standing bear is the quickest and runs from eight dollars on up. The stores down here like Turquoise Village are where I sell them. The store would charge from sixteen to twenty-four dollars for them.

The most unusual piece I've ever made was this cedar [carving]. It was out of cedar. We went up into the forest to get some cedar to use for my carvings like one of them we used to do. There was this one piece that I got that gave me the idea. The shape of it gave me the idea of a fish with two bears on it. Instead of the bear eating the fish, the fish was diving with two bears!

I make fetishes to see how far I can go into my creative work. It's a part of me and a part of my family's tradition. Tradition just keeps it going. When I go down to my grandma's, and I walk in, she has music on loud, and, once you walk in there, it's just like life. It's happiness, you know. It brings you happiness when you walk in.

She records the music from the dancers, the Night Dancers. Well, all the songs, what they talk about is life and the worlds, how to grow things and how to live your life. What Zuni words I know, I just listen to it. Then I just get the idea of what they are talking about, and when the rains come, all that stuff. It's interesting once you get into it, and you listen to it. The rhythm of it makes you want to dance.

I started by watching my uncle carve with his music playing and by listening to his stories. It just got me interested in following my own religion and keeping it going and never letting go of it. They remind me to make my prayer sticks. It's an ongoing thing. It's your religion, and it's what you were brought up with, so I just keep on doing it 'cause you can't let it fade away.

One of the fetishes Joseph regularly

makes is an Olla Maiden with intricately carved clothing, inlaid slanted turquoise eyes, round mouth, a necklace, and dots in her robe. Because he carves such a detailed three-dimensional piece from a red mineral slab and because he likes to display his pieces in the black velvet box, Joseph makes the back of the Maiden flat. The back also has turquoise dots and carved flowing hair extending to the figure's feet. Joseph has told the story of the Zuni supernatural in stone. She is ancient and ageless. (Plate 8)

Fetish carvers of Joseph's generation at Zuni in the late 1990s fall into two groups. One consists of members of families who have a long history, across many generations, of being artists, usually jewelry makers. Joseph and Rick Quam come from such a family.

Helen's son, Franklin, and Scott Garnaat do not identify themselves as members of art families. They are a new type of Zuni artist—young men, most of them under thirty—who have learned to carve from their peers rather than from their families. There are hundreds of them. Fetish carving is well on its way to becoming the greatest source of income at Zuni. Two recent books on Zuni carving listed 298 and 236 carvers; each lists some not included by the other, and each was out of date by the time it was published.

Joseph carves bears and supernaturals in expressive detail. Franklin and Scott carve in a realistic style. Rick carves in a style based upon earlier, less detailed fetishes.

In November of 1995, we arranged for Franklin, Scott Garnaat, and Rick Quam to make a presentation about their art at Holbrook High School in Holbrook, Arizona. Following is the transcription of their presentation.

Scott: I was helping them out, so I started picking up scraps and started perfecting my carving on eagles and bears with all kinds of rocks: marble, dolomite, turquoise, fluorite, alabaster, and serpentine. It started getting to where things looked almost real. If it looks real, it will sell better. (Plate 9)

Rick: Back a long time ago when our grandfathers were carving, they never had any tools then like we have the advantage of today. Back then, they used to use rocks like flints like they used to make arrowheads. They would chip away to make the animal. So they made them look traditional like this without too much detail, where if you can use a Dremel [a small electric tool], you can make it real detailed where a long time ago they couldn't.

Each family has a different style of carving. Scott and Franklin's carvings have a lot of detail in their lifelike animals, but I do a more traditional style of medicine bears and the corn maidens. (Plates 10–13)

Franklin: I started out about like this. I needed some cash. My uncle told me to pick up a rock and see what I could do. The first thing I tried to do, to make, was a bear. I kept trying and trying 'cause they weren't coming out right. Then finally, it started turning out right, so I started making more and more. I got tired of making traditional, and I needed more cash, so I started trying to make more detail work.

The first detailed animal I tried to make was an eagle, and it took a while for me to make 'cause I didn't have a Dremel, and I didn't have a motor. I used a razor blade, files, and sandpaper. After I finished that first detail work, I sold it. I bought me a Dremel. I bought me a motor, and I started from there.

Rick: Dolomite is the first rock I ever worked with, and I've stuck with it. I've picked up other rocks, like this one, I picked this up at Nutria that looked like an eagle, so I took it home and carved it. I got the head and everything. I looked at it for hours. I put my imagination into it. You can see a bear on it with mountains and snow on the mountains in the background on the front. And on the back, I've got a deer jumping over a river with the moon and the Zuni rainbow going over. The first person I showed it to was my mom, and she liked it, so I gave it to her for Mother's Day.

Franklin: There's different types of traditional fetishes. There's plain ones and there's ones with arrowheads on them.

The arrowheads mean that blessing to the spirit of the animal.

Rick: But right now there's a problem with the buyers. Some of the buyers are coming into Zuni and buying fetishes from us—us carvers, and they are sending it overseas just to make money, make a quick dime, and they ruin our name while we work so hard to make our name.

Franklin: I used to work a lot with Picasso marble, but I like to change. What people like now are expensive rocks with lots of color. Just depends on what the buyers want. They tell us what they want. There's a lot of range from a couple of dollars to a couple of hundred of dollars for a fetish. It all depends on the rock and the amount of detail.

Scott: My favorite stone is always and always has been Picasso marble because it carves up so nice. You can do anything with it, and it almost never breaks. Then I get involved in more expensive stones 'cause they have more resale value. At first we carved for the money, but now—

Franklin: Now I respect it more.

Rick: Whenever you take up a hobby, like basketball, you have to learn how to do it to enjoy it, and that's what we have to do, is learn how to carve in order to like it. And now it's not a matter of liking it. It's loving it. It will give you time to think and to be alone. That's when your mind takes over.

I've seen Franklin when he was like out-

rageous. It was unbelievable. He made an eagle one time detailed like that, sitting up, and I couldn't believe it. I kept wondering how he kept the wings on that rock without them breaking. It was just the prayer he did or something.

Franklin: [shaking his head] No-o-o-o. I sat at the motor twelve hours straight.

Scott: How long it takes to make a fetish depends on what kind of rock you use and how big you make it. Small ones, if it is simple, can take anywhere from five to ten minutes. If it's got detail, it can take an hour, hour and a half.

Franklin: Zuni fetishes are internationally known.

Scott: They've got their own place in the stock market.

Rick: The Wall Street Journal says if you want to invest in the Native American market, you should invest in Zuni fetishes.

To evaluate how good a Zuni fetish is look for scratches, cracks—if they had superglued a broken place—

Franklin: People like it more when it's unusual.

Rick: Some carvers just crank them out so fast that they are flat, have no detail. That's what we call road kill.

Scott: They crank them out so fast, there's no heart in them.

Rick: Just look at them and compare them.

Franklin: —the shine—

Rick: I made a fetish with a heartline. It's hard. You have to have strips of turquoise—

Scott: —and make sure the ends are straight.

[The heartline—the arrow outlined sweeping from the animal's mouth to the middle of its body—is one of the most pervasive images in Zuni fetishes. As an introduction to his report about fetishes, Cushing said that the Zuni believe that animals charm and capture their prey with the breath from their lungs and hearts. The heartline may be based upon this belief. It is not included as a part of most traditional contemporary Zuni fetishes.]

Rick: A friend of mine gave me a boar's tusk, tooth which is about this big, you know. You have a root on it. Sideways, it looks like a moon. I put a corn maiden on it. The buyer got $260 for it. And I was proud of that. I took time on that—a long time.

Franklin: My favorite fetish would probably be the one that started me out— that eagle. I tried for a lot of detail. I tried and I tried and over a period of time, I got to know how an eagle is.

But I do so many. It's hard to have a favorite. I see fetishes I made six years ago, and I laugh, but the animal's still in it. I'm learning.

Rick: When you look at a rock, you see the texture—sometimes something in the color—different things in the rock that will make it stand out more.

Franklin: Sometimes if you have a good imagination, when you see a rock, you will see that there is already an animal form, and you know what to do.

Rick: Like this one. I saw the eagle in it.

Scott: I sign my pieces, most times.

Franklin: I sign my pieces, but sometimes I forget. If there's a rush, an order [looks at all of his pieces in front of him]. But right now I don't have nothing signed. I guess I'm always in a rush.

Franklin and Rick: [talking together] A lot of Zuni carvers are better known than we are. There's the Quandelacys, Stewart's family. They're known for their corn maidens. There's the Leekyas. There's books of people who are famous carvers.

Scott: We are in one book, but we aren't the best yet. We help each other out. We're all cousins.

Rick: In the way we grew up, we're all brothers.

Franklin: I started carving when I was fifteen. I saw all my friends partying, and I thought, 'I want to do that,' but actually I was always in front of my motor wracking my brain, but it paid off. I don't drink, and I have money for the things I want.

To my elders, fetishes are used for religion and personal uses. Nowadays, that's all changed. Things have improved. People in Zuni are just making fetishes for self-employment, sort of like a side job. They come home and carve out their fetishes and make more money. In Zuni belief, there's a lot of different stories to fetishes and how they evolved, but for my part, I am just looking for cash.

Rick: The different animals that are carved are pointed in different directions. In our Zuni belief, we have six directions, and each direction varies depending on what set of fetishes you want for the hunter, or for personal use, or just to protect other people. Say like you have a child born into the world. A fetish will be given to that child throughout his lifetime, and by the time—say if it's a boy—by the time he's old enough to be a man, he'll have the whole set given to him by his father or somebody else like his uncle who will care for him later on in life and teach him the traditional ways. Some of the stuff are very powerful to us, and that is the stuff that we don't sell or we give them to our friends or somebody who needs that the most. We just don't make them to sell to make money. We do this for our religion. It's a belief, too.

Franklin: I don't try to do traditional very much anymore because detail and lifelike sell for more.

Rick: The arrowhead is an offering to the spirit of the bear. It protects that person who is going to be holding that bear—guides that person, protects, and serves as a god to who believes in him. If you have a bear, and you're just tossing it around, that

bear's going to punish you for what you're doing to it, so if you have one, treat it good, feed it, talk to it. It will protect you and your loved ones as long as you treat it right. If you throw it around and disrespect it, that's how it's going to treat you, and later in life, it will really punish you.

Franklin: They used to be carved for religion purposes, but now they are mass-producing fetishes as works of art—

Rick: —but the elderlies still carve the traditional crafts and use them in religious ceremonies. Those aren't the ones to be sold ever because they have been prayed over and blessed, and those are like the moles who take care of the underworld.

There's different animals for each direction way. The eagle is the one that rides the sky and watches over us. It depends on what set you want. There are a set of six fetishes for a person who is a hunter. There are certain fetishes that go with it, and like family—to protect your family—take care of loved ones. There are other ones that we use for religious purposes.

Scott: A lot of the older, older fetishes were just natural shapes like animals, and all they had to do was smooth off the bottom, put eyes on them, and tie an arrowhead to the back. Those had a lot more spirit inside them—the spirit of the animal.

Rick: And they are all important. The frog takes care of the water and things in the water. He brings you water. A long time ago at Zuni when the people were wasting water, that was the only way the frog transported water, in his throat—that big thing—that's how they drank.

There was a snail that tried to bring water, but he went so slow, he wore a hole in his shell. Everybody was glad to see him, but he didn't know the water had leaked out, but where he went that made a wet trail. That trail became a river. That's how Zuni got its river.

The Zuni economic structure began to change in the late 1980s when those with New Age interests created an almost insatiable market for fetishes by making them sacred again in new ways and incorporating them into beliefs and practices. One book, for instance, encourages combining the use of Zuni fetishes with modern self-help systems and explains how to receive fetish readings and how to use them. The Zuni government has opened two stores in southern California. The yearly output of these inexpensive fetishes may now be in the hundreds of thousands (Joseph says that he himself has made thousands).

The carvers feel the tension in this situation—the difference between their art being seen as a sacred undertaking and as a vocation. They are cognizant of the long history of fetish making and of the beliefs among their people. Much of what Cushing

reported is still in their thoughts. They are also aware of the wide range of fetish use in contemporary Zuni practice. Generally, they see a difference between a fetish—a Zuni carving that is owned and used by a Zuni and has been blessed by the proper Zuni priest—and a carving that is made for sale. They take a quiet pride in their carving, and they recognize and admire each other's work, seeing themselves as a group and speaking of "our" name. They remind us that now, as in Cushing's time, stories live in the stones. They are concerned with the aesthetics of what they produce, and all have made pieces requiring extra time which they and other carvers consider superior art.

When we told Franklin we would like to interview him alone about fetish carving, he suggested that it would be a good idea for us to photograph him making an item "from start to finish," and said that he would like to make a bear for me to carry in my medicine pouch because "bears are for health."

Franklin began making the bear, which would have a black arrowhead tied to its back, by choosing a cut piece of azurite. He shaped the piece quickly and expertly by manipulating it against the stone of a bench grinder. He stopped several times and placed the emerging form on his work bench for us to photograph.

After he finished shaping the bear, he made two tiny eye sockets with his Dremel hobby drill. Choosing jet for the bear's eyes, he took a preshaped, rod-like piece, glued the end of it into a socket, used nail clippers—calling them his "secret Zuni fetish carvers' tool"—to cut it flush, and repeated the process to make the other eye.

Next, Franklin took another piece of jet—a dense black mineral that takes a high polish—and used the grinder to shape it into an arrowhead. He put a polishing head on the grinder and polished the bear and arrowhead with buffing compound. Finally, he wrapped a piece of artificial sinew around the arrowhead and bear. His cousin helped him glue the sinew in place, and a bear was born.

Looking at the pictures of this process later, we were struck by one image in particular: Franklin bending over his wheel and looking intently at his work with the dust of ancient azurite on his cheek. This image is a metaphor illustrating the Zuni monistic view of time. The carver is young, the dust is old, and the two are one.

Franklin has made many of these bears for friends and family or to sell. (Plate 14) A quite different process took place in the making of what I consider to be one of his masterpieces. One day when Franklin was unloading the trash at the dump, he found a small piece of abalone shell someone had discarded. He took the piece home and thought about what he could make from

it. He said, "When I found this, I spent a lot of time just looking at it, letting it tell me how it should be." Finally, an idea came to him, and he carved a horned toad.

Franklin had made other horned toad fetishes before, and has done since, carving most of them quickly with power tools; they are among his less expensive pieces. (Plate 15) But this one, made from the piece of abalone shell he found at the dump, is a different creature. (Plate 16) Because of the piece's small size and because of what it told him it wanted to become, he hand-carved a three-centimeter fetish from it. He incorporated the natural colors of the material into his design so that the tip of the tail is red-orange, the body a different color, and the exquisitely detailed head a third. The feet and the horned ruff are also finely detailed, and the underside of the toad's head has natural striations that echo the shape of the real animal's mouth. This piece contains beauty and power, as do Franklin's bears.

He gave me the azurite bear.

The abalone horned toad he gave to Kathy.

Pottery and Its Makers

Franklin's sister said, "Making a pot is a lot like making a fetish. You begin with the earth. You work with it. You put in a life to it. In the end, it's a one-of-a-kind thing. That's its life."

She was right. Traditionally, Zuni pottery making, like fetish carving, has begun with the earth and ended with an embodied spirit. Pottery and fetishes share decorative elements. Some fetishes have been made of clay. Clay animal figurines are shaped and used as fetishes by Zuni families as part of an annual ceremony. However, although there are some similarities, the two art forms have had different audiences and therefore different histories.

At the center of the recent recognition accorded American tribal traditions are the potters of the New Mexico and Arizona pueblos. Through museum displays, competitions, demonstrations, festivals, and art shows, Zuni potters have recently become a part of the Native American art renaissance. Pottery has been undergoing a revival at Zuni since the 1970s and has become a major source of income for many of the village's inhabitants.

Franklin's mother, Helen, is a Zuni potter. Between 1974 and 1989, she designed, shaped, painted, glazed, and fired over a thousand pieces of pottery, which are now in museums and collectors' homes. She also painted, incised, and had commercially fired an unknown number of greenware lamps. Helen's work includes water jars, coffee mugs, canteens, and bowls, but she is perhaps best known for her effigy pots— realistic, vibrant miniature duck, owl, dog,

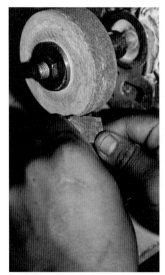

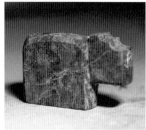

Bear after its first shaping.

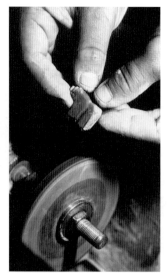

Franklin shaping the
azurite bear.

Final shaping.

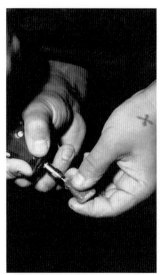

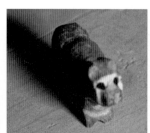

Finished eye sockets.

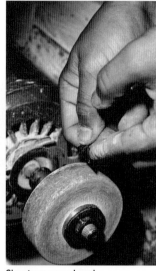

Drilling eye sockets.

Shaping arrowhead.

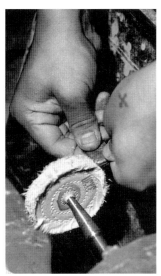

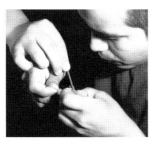

Attaching arrowhead
to bear.

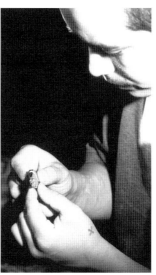

Polishing bear.

Franklin examining
finished bear.

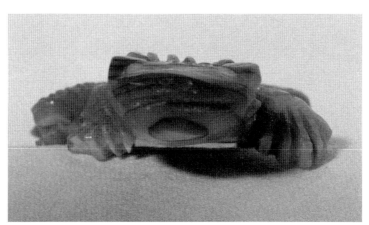

Franklin's abalone horned
toad's mouth.

bear, turkey, turtle, and deer figurines—and for the decorative hanging lamps she invented. (Plates 18–20)

The oldest pots found in the Southwest date to about 300 B.C.E.; the earliest known pots associated with the pueblos were made around the time of the birth of Christ. Beginning in ancient times, thousands of pottery styles—many known only from archeological records—have been developed and used by the pueblo peoples. Big pots and small pots, water jars, storage jars, and miniature animals designed for play or ceremony have been made in myriad colors and combinations. The most common early color combination was black and white; black paint made from boiled bee plant was put on clay made white by a kaolin mineral slip or wash or on clay that turned white after it had been fired. Hundreds of black-and-white styles can be found in the potsherd scatter that covers the land.

The pueblos are many and varied. From prehistory to the present, the Zuni have had a great deal of interaction with Hopi, the pueblo villages located on the mesas north of Flagstaff, Arizona, to the west of Zuni. Zuni and Hopi share so much history and material culture, in fact, that they are called the western pueblos. One commonly reported story is that large groups of Hopi went to live at Zuni following the great smallpox epidemics of 1775, 1883, and 1884, remaining there for several years

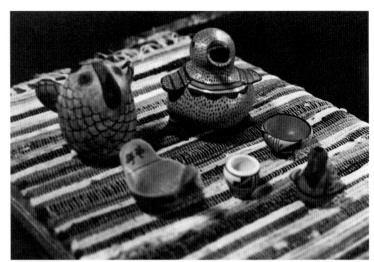

A collection of Helen's pots.

before returning home. Also according to stories, other groups made similar sojourns after periods of severe drought.

Prehistorically, both cultures were part of a great trade network that spanned the continent and reached deep into Mexico and even to Central America. Pottery was among prehistoric Zuni's major exports, and recognizable Zuni pots or sherds have been found in, among other places, excavations at Acoma Pueblo and in the ruins of the important Chaco culture in the Four Corners area where Arizona, Colorado, New Mexico, and Utah come together.

There has been a great deal of trade and interaction between Zuni and Hopi in more recent times as well. Helen's great-grandfather was a professional trader who regularly gathered packs of Zuni goods, traveled the two hundred or so miles

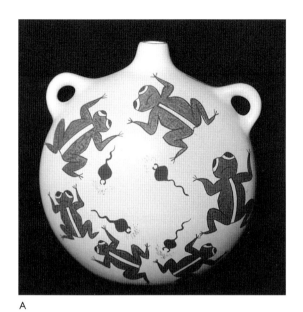

A

A
Canteen made by Helen.

B
One of the first jars
Helen made.

C
Duck effigy. This is one
of the few ducks Helen
made with feet.

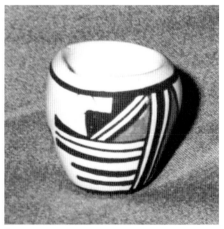

B

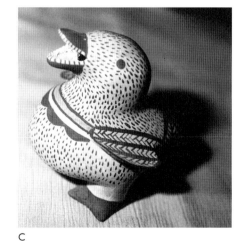

C

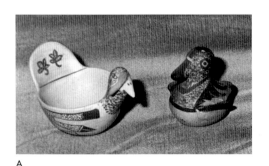

A

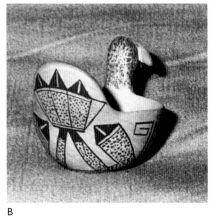

B

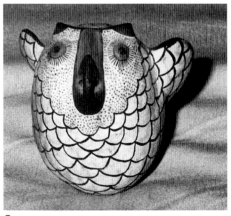

C

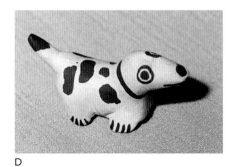

D

A
Turkey and duck effigy pots by Helen.

B
Another image of the turkey effigy pot by Helen showing the design she painted on its back.

C
Owl effigy by Helen.

D
Dog effigy by Helen.

of trail from Zuni to Hopi, traded, and brought Hopi goods back to Zuni. It is clear that members of the groups often walked back and forth and attended ceremonies at the other villages. One story tells of Hopis and Tewas, another tribe, returning from their annual trip to Zuni in 1897 and bringing smallpox back to their village.

Styles of Zuni and Hopi pottery have often intertwined. Among the most recognized and praised examples are the polychrome pots, on which two colors of paint are added to a base of a different color or to one washed white. Two types of prehistoric polychrome pots of the Zuni and one of the Hopi and a related Hopi type found with it can be seen today in potsherds and museum pieces. Reinterpretations of these styles are evident in contemporary pieces, including Helen's pottery.

Hawikuh, a major prehistoric Zuni village, was founded around the time William the Conqueror defeated the Saxons at the Battle of Hastings in 1066, and was abandoned sixty years after the landing of the Pilgrims at Plymouth Rock. Over those five hundred or so years while the village flourished, the Zuni potters of Hawikuh created two polychrome pottery styles highly regarded in our time. The village was abandoned by the Zunis after the Pueblo Revolt in 1680. The making of Zuni pottery waxed and waned during the next several centuries.

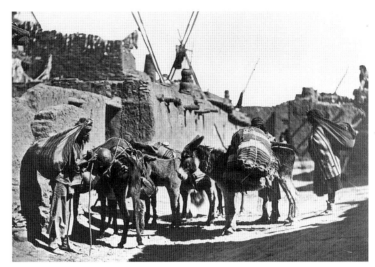

A Zuni street scene showing man loading burros, 1879. Almost nothing is known about this photograph, but its date is such that the man shown could have been Helen's trader great-grandfather. (Photo Number 72.754. Courtesy Museum of Northern Arizona Photo Archive.)

The Hopi village of Sikyatki was founded in about 1300 and abandoned around 1550. During the 250 years or so while the two villages coexisted, Hawikuh and Sikyatki shared one of the most highly regarded pottery traditions in the history of the world. The styles were similar in form, color, subject, treatment, and use of space.

The bowl is a form common to all of these polychromes. In Sikyatki polychrome and Hawikuh polychrome 1 and Hawikuh polychrome 2 (these are Ruth Bunzel's terms), black and red mineral paints were used; in Sikyatki polychrome and Hawikuh polychrome 2, potters used orange shades that contrasted with red and brown and also with black. Hawikuh polychrome 2 and Sikyatki polychrome are perhaps most alike in that the potters used birds and other animals as subjects for their paint-

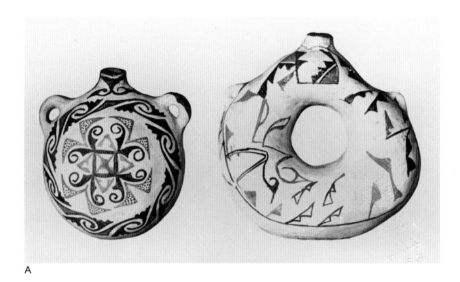

A

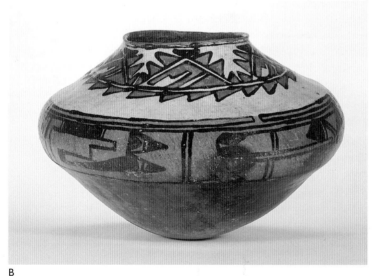

B

A
Hawikuh polychrome I
canteens. (Negative Num-
ber 25689. Courtesy Mu-
seum of New Mexico.)

B
Hawikuh glaze-poly-
chrome jar, ca. 1680.
Most of the known
Hawikuh polychrome
bowls and jars were
found by Frederick Hodge
in burial sites, and the
organizations which own
them have decided to
discontinue permission
to reproduce images of
them. This example of
what Ruth Bunzel called
Hawikuh polychrome II
has a different history.
Sometime before 1680,
the jar was either made
at Hawikuh and traded
to Acoma or made at
Acoma in the style of
Hawikuh. The jar was
handed down as a family
treasure for over two
hundred years and then
purchased at Acoma by
an Anglo-American col-
lector. (Photograph by
Douglas Kahn. Catalog
Number 7832/12. Cour-
tesy School of American
Research Collections
in the Museum of New
Mexico.)

ings; the pieces often featured a single, conventionalized bird or animal figure. Both styles also have a great deal of empty space in their designs.

In the late 1800s, the Zuni produced an aesthetically outstanding pottery type that reached a rarely achieved degree of artistic perfection. Zuni polychrome, or "classic polychrome," as it is sometimes called, combined geometric design elements and stylized animal figures in lush, detailed paintings. Pieces based upon the classic type of the 1800s continued to be made in decreasing numbers at Zuni through the first third of the twentieth century, although pottery making never completely died out. By the first decade of this century, however, the entire tradition, as measured by the number of items produced and the market for them, was clearly in decline.

Also in the late 1800s, Hopi developed a contemporary traditional ware designed to be sold to tourists. The style copied Zuni classic polychrome but was generally regarded by experts as inferior to the original. By the last decade of the nineteenth century, Hopi pottery traditions, too, were in decline. Pieces based upon the classic type of the 1800s continued to be made in decreasing numbers at Zuni through the 1930s, and Hopi produced ware that was well painted even as its ceramic qualities suffered, but it seemed that both traditions might fade away.

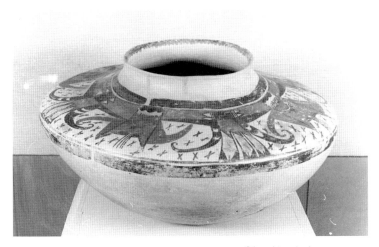

Sikyatki polychrome jar. (Photo by Mark Gaede, Photo Number 74.036.267. Courtesy Museum of Northern Arizona Photo Archive.)

Collectors and scholars alike refer to the Hopi pottery tradition between about 1650 and about 1880 as a time of slow decline in terms of quality and quantity. The end of the decline and a new beginning took place in the late 1880s with a Tewa potter named Nampeyo.

In 1895, J. Walter Fewkes, the anthropologist who made pioneer field recordings of Zuni music with an Edison cylinder phonograph and studied the Sinagua (ancestors of the Zuni and the Hopi) ruins on New Cave Hills, began an excavation at Sikyatki assisted by Frederick Hodge, who had been Cushing's field secretary during his 1887 research on other pueblo ancestors in the Salt River Valley south of Phoenix, Arizona. Sikyatki ruin is located about two miles northeast of the Tewa village of Hano in the Hopi homelands. The ruin was already well known by

Hopi and Tewa potters who went there—particularly after hard rains—to gather potsherds as inspiration.

The dig uncovered a mortuary site and two very different pottery styles. The older style is made up of yellow ground decorated with simple patterns in brownish-black paint. The patterns are almost always angular, geometric, and nonrepresentational. The second style is the famous Sikyatki polychrome with curvilinear patterns that often include realistic representations of life forms.

The area's best-known potter at the time of the Fewkes excavation was Nampeyo, a Tewa who lived in Hano. (According to a widely distributed historical legend told by the Tewa even today, a group of Hopi leaders asked the Tewas' ancestors, known for their skill and courage as warriors, to migrate to Hopi and defend the land against attack. The Tewa left their homes in northern New Mexico and arrived at Hopi around 1702. The legend tells that the Hopi refused to honor their promises and allowed the Tewa to settle only after they had won a great victory against the Utes and that the Tewa placed a curse on the Hopi. These events created an enduring tension. The Tewa have lived among the Hopi for over two hundred years, but have retained their own culture and language. They are the eternal strangers.)

Nampeyo, who was fascinated by

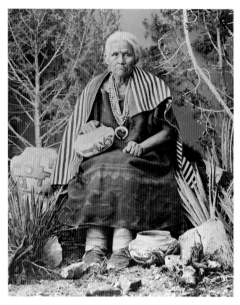

Studio picture of old woman holding pot. The pots shown are Zuni classic polychrome. (Photo by Ben Wittick, Selgem Number 92.1.864. Courtesy Maxwell Museum of Anthropology.)

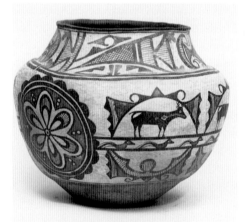

Jar—polychrome, Zuni pueblo, ca. 1880–1900. (Photo by Arthur Taylor, Negative Number 85704. Courtesy Museum of New Mexico.)

pottery, had started to make pieces re-sembling those of her Hopi neighbors. She gathered and studied Sikyatki polychrome potsherds, and experimented with the clays, paints, and techniques used by those skilled potters of long ago. Nampeyo vis-ited the Fewkes dig and examined at least some of the over five hundred complete Sikyatki pots and thousands of Sikyatki potsherds uncovered. She had already begun moving in the direction of revival; the dig further inspired her, and she went on to develop a pottery style based upon the past.

Although she was inspired by the de-signs on the Sikyatki pottery and pot-sherds, she was also highly creative in her expression. In some of her most beautiful pots, she used the polychrome technique of the second Sikyatki style and the angular geometric patterns of the first Sikyatki style. In her later years, as she was losing her eyesight, she chose the angular geo-metric figures over realistic design more and more.

Nampeyo's work is so unique that her pots and those by people who learned from her are usually referred to as "Hano polychrome." The pieces have a fugue-like quality, with complex countrapuntal repeti-tions of design elements based upon Nam-peyo's interpretations of Sikyatki pottery. Thousands of tiny dark brown or black bee plant and red mineral parallel lines have been applied with infinite patience and

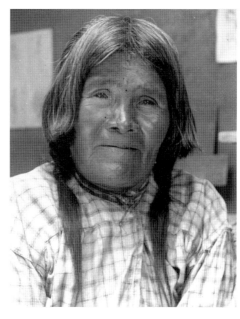

Nampeyo. This picture was probably taken in 1915. (Photo by Emery Kopta, Photo Number 240-2-88. Courtesy Museum of Northern Arizona Photo Archive.)

precision—and a mastery of design and perspective—to clay that is brown or is coated with a white slip.

Nampeyo became famous. She made only three major trips from her home to demonstrate her art—two to the Grand Canyon and one to Chicago—but many museum buyers and thousands of tourists came to her. She was accorded a level of recognition rarely achieved by living art-ists, being acknowledged to have begun and directed a movement in art during her lifetime. Today she is widely regarded as one of the greatest and most influential of American ceramicists. She not only started a style that is still associated with her and her descendants but also changed Hopi

37

pottery so that much of the modern work is based upon Sikyatki pottery and Nampeyo's interpretations of it.

There has been speculation through the years as to why a Tewa potter making the Hopi ware of her neighbors based upon Zuni patterns would have turned to prehistoric Sikyatki pottery for inspiration. Since Nampeyo neither read nor wrote (and spoke no English), she left no journals or diaries, but her pots tell of her artistic abilities. Even today Sikyatki pottery is widely regarded as among the most artistic pottery ever known, so it is not surprising that it appealed to Nampeyo.

The Sityatki dig was important for another reason, too. Fewkes and others of his time were convinced that Indian cultures would soon disappear. They set out as individuals and as buyers for museums to salvage as much of it as they could, thus creating a market. Collectors and anthropologists recognized Nampeyo's work as exceptional and spread the word through books, articles, and personal communications. Tourists took railroad side trips to Hopi and bought souvenirs.

Edmund S. Curtis, the best-known early photographer of American Indians, visited Hopi and photographed Nampeyo many times (after combing out her traditional Tewa hairstyle). She was photographed by others as well, being mentioned and pictured not only in scholarly publications but also in advertising campaigns. The

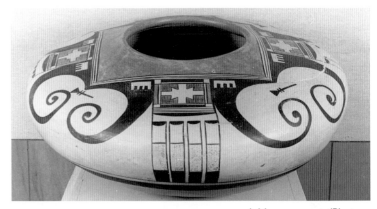

A Nampeyo pot. (Photo by Mark Gaede, Photo Number 74.046. Courtesy Museum of Northern Arizona Photo Archive.)

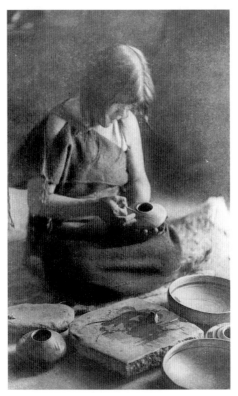

"The Potter." This famous Curtis photo of Nampeyo is dated 1906. (Photo by Edward S. Curtis, Negative Number 130951. Courtesy Museum of New Mexico.)

best of Nampeyo's work transcended culture and has eternal appeal. It is, however, at least partly because outsiders bought her work that she became so well known and influential while remaining a traditional Tewa.

The story of the rediscovery of the Hawikuh polychromes is also interesting. Frederick Hodge, probably because he had served as Cushing's secretary in 1886 and with Fewkes during the 1895 excavation of Sikyatki, was chosen in 1917 to direct the excavation of Hawikuh. (As we learned earlier, Hawikuh was the largest of the Zuni villages when the Spanish arrived; it was the site of the first Spanish mission at Zuni, built in 1629, and was abandoned after the Pueblo Revolt in 1680. The village and the mission crumbled and were covered with the debris of centuries.)

Hodge's six-summer program from 1917 to 1923 was one of the most extensive archeological studies undertaken in the Southwest. He uncovered about a thousand burial sites and over fifteen hundred pieces of pottery. The pottery was of many types and represented a long period of Zuni time, but the two most beautiful styles were contemporaneous with and probably directly related to Sikyatki. Zuni, however, produced no Nampeyo, and the dig had little direct, immediate influence upon Zuni pottery.

There may, however, have been long-term, indirect influences. Daisy Hooee

(1905–1994) was Nampeyo's second granddaughter. As did many of Nampeyo's other grandchildren, Daisy stayed with her grandmother in order to attend school, and she played at making pots from tortilla dough. She would make coils, shape the pots, and dry them under the cookstove; then, as she said, "I eat them." When Nampeyo discovered a batch of drying dough pots, she volunteered to teach Daisy how to make the real thing.

Like her grandmother, Daisy was slowly going blind. Fortunately, a wealthy woman from California, Anita Baldwin, was on a camping trip near Hopi and discovered the little girl who was desperately in need of eye surgery. She arranged for Daisy to come to California, financed the surgery, and took over her education. Mrs. Baldwin cared for Daisy during her high school years, arranging for her to go to Paris and study sculpture at the École des Beaux-Arts. After Daisy finished there, Mrs. Baldwin took her on a tour to study art traditions around the world.

When she returned home, Daisy continued her work as a sculptor and a potter. An influential trader of the time commissioned her to make a series of statues from large pieces of turquoise; however, as there was not enough turquoise available in pieces of sufficient size, she began working mostly in pottery, in the style of her grandmother's revival. Daisy particularly liked little pots, both for aesthetic reasons

39

and because they were easier to make and sell. She was noted for her little "ant pots," which were decorated with lifelike figures. (Plate 21) Nampeyo had told her and the other grandchildren a story about people of long ago making little ant pots, baiting them with honey, and, when all the ants were eating, picking up the pot with a stick and moving it far away so that the ants would not bite the children. She told the children that the ants dressed up in butterfly wings and little bird feathers and had dances in their village.

Daisy Hooee married a Zuni man and moved to Zuni. In 1974 she began to teach a vocational development course in the making and selling of pottery. The idea was to provide Zuni women with an opportunity to learn to produce and market pottery so that they could earn money in a culturally accepted manner and also create a cottage industry that would help alleviate the chronic unemployment and low income levels of the pueblo. The school itself was a tourist attraction; students took people through the facility explaining the pottery-making processes and answering questions. They received a salary for participating in the program, and they sold the pottery they had made in their classes and even potsherds they had gathered.

Daisy taught the women how to make pots as she herself had been taught by Nampeyo, and, equally important, instructed them in marketing the work, at which she had become very skillful. Nampeyo had never learned to read or write, and had never signed her work. Her daughters signed her name to a few pieces, and, going against the communal traditions of the pueblos, signed their own work, too. Daisy had learned from her mother and aunts as well as from her grandmother, and she stressed the importance of signing and dating work as a sales technique, even though many of her students felt uncomfortable with the idea.

One of Daisy's students was Helen, who was able to learn about the traditional paints, slips, and techniques of making and firing that Daisy had learned from Nampeyo. Helen looked at designs in an old book of Daisy's, and, later, Margaret Hardin, a consulting anthropologist from the Smithsonian, showed the class photographs of many types of early Zuni pottery, including polychromes and effigy pots. (At Helen's request, we also made photocopies of Zuni pottery designs from standard sources and gave them to her.) Helen began her work making bowls in the classic polychrome tradition but later chose to make effigy pots—three-dimensional representations of animals and persons— and also created hanging pottery lamps which in many ways resembled Hawikuh polychromes.

Helen said that she decided to make effigy pots because she thought they would be the most difficult to do of all the old

pots she had seen. She liked the challenge of miniatures and the fact that she could make many of them with the same amount of clay required to make a big pot, thus having money coming in over the whole month.

Three pieces representative of Helen's work are a bear with a heartline (Plate 22), a turtle, and a hanging lamp. The turtle combines lifelike form—and a smiling face—with highly stylized geometric designs. The bear is extremely realistic and lifelike, with skillfully shaded ears, painted toes, and a pointed tail. The heartline is one of the most pervasive elements in Zuni pottery, commonly used as a part of the design called "the deer in his house." The overall design and execution are so effective that, as one collector said, Helen's creatures have a lot of life about them, but the painting on these animals is perhaps their most striking feature. The lines, black and red, are small, close together, and done with a sure hand; the polychrome designs are masterful. Helen says that the hardest thing for her to learn about pottery making was how to paint the way she wanted to; she can look at a piece and date it by her steady improvement in this area.

The hanging lamp is painted in a traditional manner, natural paints and yucca brushes being used to fashion an elaborate, three-dimensional village featuring a stylized pueblo, the face of a supernatural, feathers, and bold empty space. Perhaps

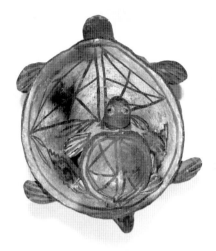

Turtle effigy, Zuni pueblo, ca. 1885. (Photo by Arthur Taylor, Negative Number 79985. Courtesy School of American Research Collection in the Museum of New Mexico.)

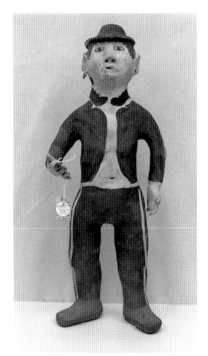

Zuni effigy. Kathy photographed this effigy when she was employed by the Museum of Northern Arizona as an ethnographic cataloger in the 1970s. The figure dates from the 1920s, and Zuni, Hopi, and Navajo museum staff called it Charlie Chaplin. (Photo by Kathryn Cunningham, Photo Number 76.240. Courtesy Museum of Northern Arizona Photo Archive.)

41

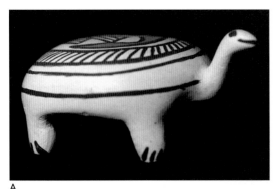

A

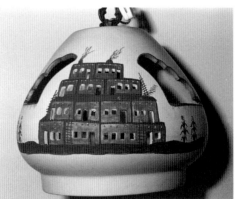

B

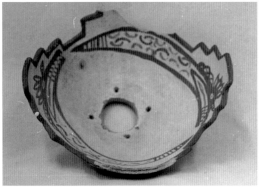

C

A
Helen's smiling turtle.

B
Village on Helen's hanging lamp.

C
Zuni bowl lamp shade. This bowl is designed for a small light bulb. (Photo by Kathryn Cunningham, Photo Number 76.506. Courtesy Museum of Northern Arizona Photo Archive.)

the most innovative aspects of these pieces are the carved design that goes completely through the pot and the use of empty space. Except for jars built as homes for fetishes, carved pots with openings are rare in the history of pueblo pottery (although they not unknown; the Barth Collection at the Museum of Northern Arizona includes three miniature lamp shades made by unknown Zuni potters).

Empty space in Zuni pottery, like silence in Zuni narrative performance, is everything in nothing, suggesting limitless and unknown possibilities. Empty space and silence draw attention to what has gone before, calling the audience to full participation. Among the Zuni and the Hopi, there are groups with differing political and religious beliefs; the factions have been described by researchers as progessive and traditional. These worldviews influence the use of empty space on pottery. An innovative study of 1980s Third Mesa Hopi traditional pottery not made for sale identified two principles of design aesthetics that correlated directly with whether the artist was affiliated with the progressive or the traditional faction.

Hopi progressives favor an overall design for their pottery with very little or no empty space, and they also fill their homes with furniture. Children painting fill their canvases with many singular elements as part of overall designs.

Hopi traditionalists place their furniture along the walls, leaving the centers of their rooms empty. They use unconnected motifs and include a great deal of empty space in their pottery. The children's drawings usually include only one design element and have a great deal of empty space.

At Zuni, the use of empty space probably has similar if not exactly the same meaning as at Hopi. Researchers have generally agreed that Zuni interior design and the Zuni psyche normally proceed by the creation of many-faceted gestalts, but that such a conclusion may be at least partly a result of the fact that most research has been done with progressives.

Helen's grandchildren's drawings would at Hopi at least reflect the progressive worldview. Franklin's fetishes are also progressive in their inclusion of great detail. This aesthetic makes sense, given that members of Helen's family have been among the leaders of the progressive faction at Zuni for over a hundred years. Her use of empty space, therefore, seems in some way out of time. Empty space is unknown and unknowable, uncontrolled and individual, requiring the audience to bring something to it. Empty space is by its very nature dualistic and creates tension. The Zuni aesthetic has been described as controlled and monistic, aiming to absolve tension by imposing tradition and overall design on empty space. The empty space

of Sikyatki and Hawikuh pottery, of Nampeyo's pots and Helen's lamps speaks volumes.

Zuni's three polychromes—Hawikuh polychrome 1, Hawikuh polychrome 2, and Zuni classic polychrome—and the patterns of Sikyatki meet in these pieces by Helen. The cloud design on the turtle's back and the heartline on the bear are best known from Zuni classic polychrome; their placement on these pieces resembles the first Hawikuh polychrome. The colors of the lamp and the use of animals as design elements are reminiscent of the second Hawikuh polychrome, with its delicate shading from orange through red and brown shades into black. The lamp's bold empty spaces evoke both Sikyatki polychromes.

Researchers have investigated the symbolism of Zuni pottery designs through time, geometric designs as well as life forms. According to Daisy Hooee's teaching, said Helen, every pot tells a story. The stylized face and feathers design on Helen's lamp is within the broad range of Zuni iconography. A sun face, it is a symbolic representation of the Sun God who created humans, and is frequently used in Zuni art. The stylized pueblo design opposite the sun face is another ancient Zuni symbol, representing its idealized self. The lifeline painted on the bear is ancient and is found on many older Zuni fetishes.

Aesthetic conventions and traditions also govern the use of geometric designs.

The curvilinear polychrome geometric design on the turtle shell was called Striped Circle (*fsipo bitsulia*) or Cloud Circle (*aweluya bitsulia*). It was identified and described by Ruth Bunzel and Ruth Benedict in the mid 1920s as a Zuni classic polychrome design element used for the bodies of water jars, and pertains to the causing and honoring of rain.

What pueblo pots past and present share most basically is their construction— the way in which they are made. Over the course of a long visit, Helen described in detail this process to us. "Before I go out to get my clay [and potsherds], I gather some food and the shovels and bags. Then, before you dig, you say a prayer and offer the food to Mother Earth for taking part of her to bring your prosperity. I always do that, right, Keith?"

"Yes, that's right," I said.

She smiled and continued her account of how to make a pot.

When I get home with the clay, I crush it and soak it. I use a hammer. Just pound it and make it crumbly. You soak the clay and keep rinsing it until the water comes clear. Then you put it through a sieve. From there it goes into another bucket to get all the clumps out so it's pretty much just a thick liquid. Then I get a frame, line it with a sheet, and pour the clay liquid into it so the water will

44

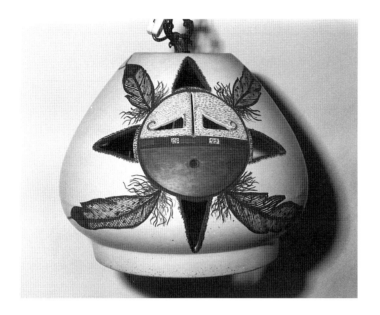

Sun face on Helen's hanging lamp.

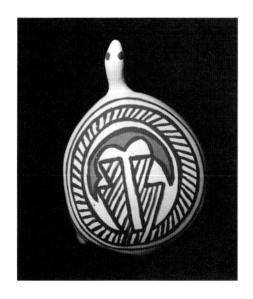

Polychrome geometric design on turtle.

evaporate. When the water is evaporated, you roll the clay up and put it in a plastic bag.

When the clay is rolled, you have your potsherds soaking. It takes about four days, and then you take them out of the water and put them on the metate grinder, and pound them until they crumble, and grind them until they are real fine. You take a handful and get your clay and mix it on the board until it quits popping. It's the air bubbles. You work them out when you mix, and you hear them popping.

Then you sprinkle in the ground potsherds [which act as a tempering agent and add strength to the pot] and knead it in and keep adding more until it is ready.

Before you start, get your stuff together. Put your gourds in water. If you have a new gourd, take it outside and break it and cut it to the shapes you want—anything from a long flat piece, or a teardrop, or a square—and then sand the edges [the shaped, sanded pieces of gourds are the principal tools used to shape and smooth Zuni pottery].

Then you are ready to coil. You can start with a base, a mold you build your coils inside. If it's going to be a big pot, you have to. It needs to be moist, and you line it, some people use cloth, with newspaper. I usually use a bowl for the outside bottom. If you see a bowl shape you like, you can use that. I like plastic bowls. When I worked at Daisy's, she had those premolded bowl starters made out of ashes. That's the old style. We had lots of molds—big ones and little ones. You could just start your coils with the tiny bottoms. For a big pot, you get a base and fill it.

Then I would start my coils. I make coils by rubbing my hands together. It's by moving your hands back and forth the same way that you make it even. Some people flatten their coils, but what I do when I make coils for walls going up is nick [makes a faint indentation with her thumbnail] the inside of my pot. Then as I put the new coil in, I just press it so it goes into the cuts I made and bonds good.

I work with a coil the size of my thumb. You rub down the inside of the bowl [with the shaped gourd pieces]. The clay goes down on the inside, and the clay on the outside goes up, and it blends into the new roll. You smooth it with the gourd. You press it in. You blend it down. That way it bonds real evenly.

You leave it in the form until it is done, and you let the clay dry until you can peel off the newspaper [and

46

Gathering clay.

Bringing clay.

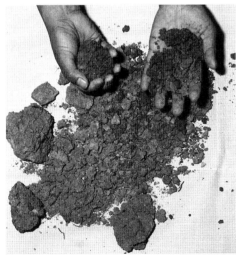

Crumbling raw clay.

Raw clay.

remove the base]. Then you let the clay that was under the newspaper dry. You do the coils all the way up.

At the narrow part, you make a lip. Nick it all around underneath, and roll another coil, and put the coil on the outside. All you do is wet your finger and spin it [the bowl], and that will make the shape you want. You use different size coils depending on how far up you want it to go up.

If the pot is too far out and you want to bring it in with your gourd, you pull it in with three motions. One and two like an x, and then up the middle, and you keep moving the bowl, and it will bring it in. You don't ever hurt clay. You can make it do what you want it to do. If you don't like it, you can change it!

Then, let it dry. How long depends on the thickness. Some people get anxious and start sanding the top. I always thought it's better to wait until it was completely dry 'cause you can weaken the bottom moving it. You put it upside down in the sun and let it sun bake.

After it's dry, you sand it. I use sandpaper, but there is a sandstone you can get. I've used screening. I always try to sand it so that it stays even. I sand the inside to touch it up.

Then you water polish it, or you use that white slip—water and clay. You dip your hand in and rub the whole bowl. I don't use a brush. A brush can leave a bristle, and you might not see it. Sometimes I've taken twelve coats just to get it even.

Then you polish it with a polishing rock. I buff it. I mean, I polish it! I'll go this way and sideways and up and down. You polish one way all around and then up and down. My polishing rocks are crystals that were tumbled. They have a good feeling, and I like the way they smooth things out. I've had some a long, long time. You polish it until everything is smooth and shiny all over. It seals it into the clay.

Next, you mix your paints and decide what kind of design you want. The first thing I do is make marks. I would make four little notches on the top, so I know to keep myself within sections. At the bottom, this part would have to be black for the earth, and I do the rain design, the rain bird design, or water bird, or whatever, or the deer in his house. (Plates 23–26)

These are prayers. You are putting your prayers on clay.

Some of the designs are for clouds and the thunder. I had pattern books [photocopied and original copies of classical studies of Zuni pottery from all periods] but made my own de-

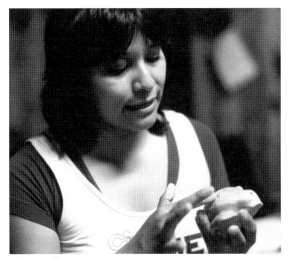

Water polishing.

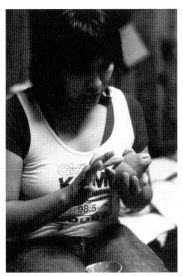

Water polishing.

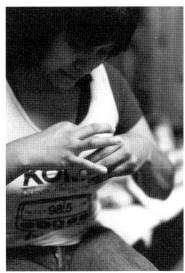

Smoothing the inside
of the pot.

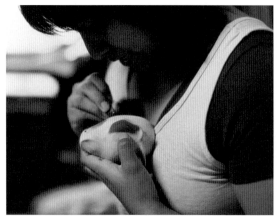

Polishing with rock.

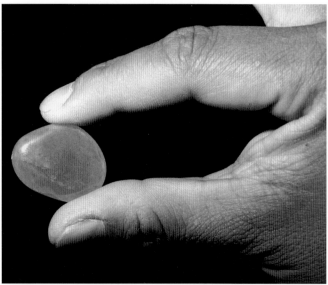

Helen's polishing rock.

signs. They are pretty similar to the old designs, but I put them together in different combinations.

I make my paints. There's the red paint made with hematite rock [ground and mixed with water]. There's beeplant [Rocky Mountain beeplant, a widely distributed southwestern wild flower classified as *Cleome serrulata* and also know as wild spinach]. You pick young wild spinach in the spring, take all the leaves off of it, and boil the leaves. Boil the liquid for days until it has a tar consistency, get corn husks, pour out the paint [into the corn husks], and let that dry. It can take months. All you need is a little pinch [from the rectangular strip that dries in the corn husk]. A batch lasts years [as long as it is kept dry].

I use yucca brushes. I don't cut until I'm ready to paint. I only take what I need. Soak them in water, take the fibers off, split them up, tear them apart, and make the shape and the size I need. You make an assortment, all sizes, from one stem. You always keep them on a plate with water [the wet yucca brushes are dipped into the reconstituted paints, which resemble modern acrylic paints in density and opacity].

Then paint the design on, turn the [kitchen] oven on at two hundred fifty degrees, and stick it in the oven, and it bakes and takes the water out and bakes the paint in.

The last thing you do before you fire it is blow into it. You blow into the bowl 'cause you're blowing life into it—your essence makes the thing you are making have a good feel to it—'cause this is Earth, and people should feel good about Earth.

Firing takes sometimes a day. The process is real long and complicated. [How long the items should be fired is determined by the sizes and number of pieces, what the fuel is and the amount of it, and the weather. A small hole is left in the traditional sheep manure pile through which the potter can look; when the pots are glowing to just the right degree, they are done. There is no formula. Traditional firing is a matter of experience and judgment.] Even after the classes were over, I would often take something that I had made over to the school—and some food. We would eat, and Daisy would fire. She did thirty-five to forty-five pieces at a time.

It had been a long, detailed session. Helen picked up one of her pottery ducks, laughed softly, and said, "Sometimes I think they are going to quack at me." (Plates 27 and 28)

51

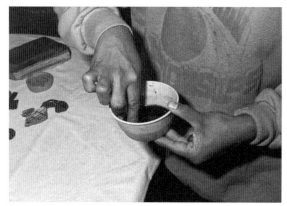

Mixing beeplant paint.

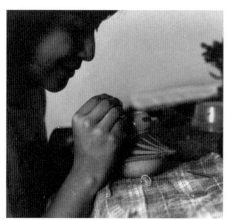

Painting with a yucca brush.

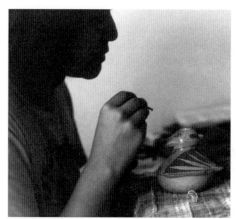

Painting with a yucca brush.

Firing is the most demanding process in the making of pueblo pottery. Firing unites pot and paint. One tiny air bubble can make a pot explode; inadequate or changing temperatures can cause a pot to smudge or develop random dark discolorations or can keep the paint from adhering. Traditional firing involves building a dome of fuel—the Zunis prefer sheep manure—over the pots, setting it on fire, and hoping for the best. It is a tedious and uncertain operation.

Helen said, "If you bring bad energy or negative thoughts into your mind, your bowl's not going to come out right. If you fire that bowl, it'll crack. A pregnant woman making a pot will cause it, or other pots fired with it, to smudge. It worked, too. It was Alice, you guys interviewed her, and it was the first *she* knew about it. Not even her mom knew, but those old ladies with fire-smudged pots knew!" Traditional firing was Helen's least favorite part of the process. She often used an electric kiln because she had just a few items to fire and because pots were less likely to explode or end up smudged.

Helen was one of the first Zuni potters to use "greenware," commercial molded pots ready for painting. Her hanging lamps were greenware pots turned upside down, painted, incised, and fired in a commercial kiln. Her invention blended new materials with new combinations of old designs and ancient techniques.

In 1989, having made over a thousand pots and lamps, Helen quit making pottery for sale and moved on to other concerns. Although she never completed the pottery course, she was the person trained in Daisy Hooee's first class who was most involved with the production and sale of pottery in the 1970s and 1980s. She said, "I had to learn everything by myself after I got out of the class, 'cause I had to tend the store when we had classes. I was in charge of leading tours and stuff, and there used to be quite a few people who came to the store, and Daisy knew that I could deal with them and sell. I was good at it." Helen kept on working with and learning from Daisy after she left the class, and she continued to develop as a potter.

There have been many attempts to revive Zuni pottery both before and after Daisy's school. Catalina Zunie, a major potter of the early 1900s and the matriarch of the family with which Ruth Bunzel stayed, was often called "the great teacher" because of her willingness and eagerness to teach others. In the 1930s, the Zuni day school taught silversmithing to boys and pottery to girls.

There is a generation of potters at Zuni now who were trained by another pueblo potter married to a Zuni. Jennie Laate of Acoma was the teacher after Daisy; her program built upon what had gone before, and she and her students produced yet another interpretation of pueblo poly-

chromes. The fact that such a class had been offered before made it easier to secure funding for another one, and there were more students because the idea was familiar (Jennie broke with tradition and taught males as well as females). There were also more knowledgeable customers. (Plate 29)

Another of the remaining active Zuni potters, Josephine Nahohai, received a grant in 1985 from the School of American Research to teach traditional pottery. In the summer of 1986, a group of potters were invited to participate in the Smithsonian Folklife Festival on the mall in Washington, D.C., and were able to examine the Smithsonian Zuni pottery collection.

In the 1990s, other teachers have offered formal classes through the Zuni school system. Noreen Simplicio had more than a hundred students in her 1990–91 classes at the Zuni public school, and Gabriel Paloma continued the classes with large enrollments.

Given that the efforts of Catalina Zunie and the Zuni day school classes did not seem to have a lasting effect, that Jennie Laate often expressed concern because not many of her students continued pottery making, and that none of the women Josephine Nahohai taught went on to become potters, it could be argued that the most important factor leading to a renewed interest in pottery making was the establishment in 1984 of a tribal arts and

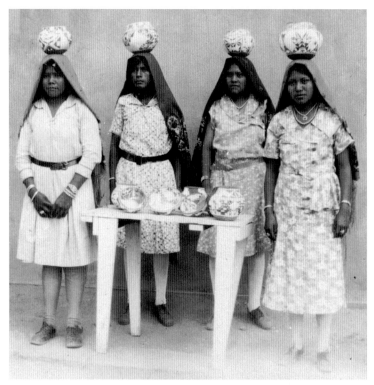

Girls displaying pottery made in 1933 class at Zuni day school. (Photo by Clara Gonzales, Selgem Number 77.45.100. Courtesy Maxwell Museum of Anthropology.)

crafts enterprise, the purpose of which was to purchase and market Zuni arts. Today there are a number of potters and even renowned pottery families at Zuni again. Leading potters of the late 1990s include Josephine Nahohai, her sons Randy and Milford, Randy's wife, Rowena Him, and five members of the Peynetsa family. Some potters, like Helen, are not from art families. (Plates 30–32)

The work of these contemporary traditional potters builds on what went before. Much of the new pottery is not fired in tra-

ditional ways for the same reasons that Helen preferred modern kilns—the group that participated in the Smithsonian Folklife Festival, for example, was not able to produce a single completed pot using traditional firing techniques during their stay there. The artists sign their work, and some of them use greenware at least some of the time. Almost all of this new pottery is painted with an overall design of many elements and little empty space. These new potters have made Zuni pottery—as interpreted by Daisy, Helen, and those who followed—a cottage industry and a major American art form once again.

The line of descent is harder to follow in terms of style than of economics, but the great prehistoric multiple polychrome tradition of the western pueblos was shared by Zuni and Hopi; it may have begun in the Zuni valley and moved to Hopi only to be lost and rediscovered at Sikyatki ruin. If so, it is fitting that Daisy and Helen brought the style home again. The present-day Zuni revival of Sikyatki style—and the much earlier Hopi one— are the fruits of seeds sowed by Nampeyo, Daisy, and Helen.

As Helen explained, Zuni pottery makes use of a tempering agent mixed into the clay to give it greater strength. The first potters to discover the value of temper probably used ground volcanic cinders. Very soon, however, someone discovered that ground potsherds worked better. As a result of this discovery, a Zuni pot made today contains around 3 percent pottery gathered from prehistoric sites. One prehistoric pot lives in many present-day pots, and these will in time break and be ground to temper future pots.

To create is to pray. Oneness, unity, monism: this is Zuni. In times past as in the present, the Zunis have been guided in their art by their worldview. Each design element on a pot has a meaning; together, the pot and its making are a prayer. The prayer is continuous; styles flourish, disappear, and reappear. Potters, fetish carvers, and families decorating their homes combine design ideas and objects from the past with those of the present to create the future. Zuni time is like that, too.

There is a second part to Franklin and Helen's story. As scholars have shown, cultural, situational, and behavioral contexts surround and govern folk art and performance, including artists, their audience, the fieldworkers who study them, and the complex interactions of all of these. In the first part of the story, we looked at Zuni culture and Zuni folk art in general, analytical terms. The next part tells of Kathy's and my involvement with Franklin and Helen, their family, and their contemporary traditional arts and of our firsthand experience with their culture, in which the processes of creation are timeless, common, and highly valued—but also tightly controlled. The artists' work and lives and our interactions with them reveal the constraints their culture places upon them. The circle continues because life at Zuni, today as in times past, is directed toward the common good.

This is the story of the *experience* of the cultural context of Franklin's and Helen's art. Here is mystery.

Helen had told us in September of 1993 about her plans to open a restaurant and gift shop. The grand opening took place that December, during Shalako, the Zuni midwinter ceremony. The Shalako was open to outsiders, and tourists and friends from around the world, including Kathy and me, were welcomed. After watching parts of the ceremony, we stopped by the cafe late in the evening. The place was packed with customers, and lots of wonderful food was being served. The Zuni art shop was very busy, too. The cafe and gift shop looked like a booming success.

Time moved on, and we worked on another project. Kathy was in a car wreck. Helen's restaurant was closed by the police.

I have no inside or even outside information about what really happened at the restaurant; there was no local news coverage. All I know is what Helen, her sister, her mother, and her children said about it. We tried to get in touch with Helen by phone and could not. Finally, Kathy called a clan sister, who said only that something had happened at the restaurant to cause the closing, but that she had no firsthand information about it; therefore, in accordance with Zuni tradition, she couldn't talk about it. She suggested that Kathy call the home of Helen's mother, Kuiceyetsa.

Helen answered the phone and said that she couldn't talk just then because they were bringing her mother home from the hospital. "I'll call you as soon as I can," she said. "But don't worry; everything's going to be all right." The days passed, however, and Helen didn't call and couldn't be reached by phone, so Kathy decided to call one of Helen's relatives. The relative said that Helen had been caught "redhanded" using the store to avoid paying

cigarette taxes, and that Helen's father, Max, was "in denial," refusing to face the fact that Helen had engaged in criminal activity and would go to jail for it. She said, "I don't know whether Helen did this herself or whether outsiders planned it and talked her into going along."

At last Helen called us. She said that she had subleased a part of the store to an outsider, and that the man who rented it was responsible for what had happened.

We were still interested in writing about Zuni art and artists so that we could spend time with our Zuni friends and also provide them with some income. We decided to take the material we had gathered through the years at Zuni and our survey and do a book with Franklin and Helen about his fetish carving and her pottery, if they were willing. We soon had a chance to propose the plan to Helen, who called our home after Kathy was discharged from the hospital. She asked, "Kathy, that woman [who was driving the car] that hit you was Hopi, wasn't she?"

"Yes."

"Well," Helen said, "I need to come to your house and cleanse it to make sure that the spirit of that woman hasn't gotten trapped. Her spirit could have gotten trapped, and she wouldn't be able to go back to Hopi. And that wouldn't be good for you guys, either!"

Helen and her sister came to our home in September of 1995. Helen "smoked" the house. It was the old, familiar Zuni ritual we had seen and heard described so often. She began by setting a mixture of dried cedar, white sage, and pine pitch on fire in a bowl. She blew out the flame. The mixture smouldered, and she carried it through the rooms, going corner to corner in a circular pattern. After she finished, she smiled and said, "It's all clean in here now. I love that smell. Doesn't it feel good in here now?" It did.

We brought up our idea for a book. She said that she would have time to work on it since the store was closed, and that she had been taking orders for pots and was going to start making them for sale again soon. She said that it would be fun to work with us on another project, and she indicated that the informant's fee would be very helpful to her. She said, "I'm sure Franklin would do it for you."

We had two long formal recorded interactions with Franklin as a part of the project. The first occasion was the making of my bear; he did a superb job of demonstrating and discussing his art, obviously having thought carefully about exactly what he wanted to say. Our second formal interaction with Franklin involved a different kind of situation. As a part of our plan to get money to the family, we had included Franklin and two of his cousins in a plan to put on a high school program (at which the

transcription appearing earlier in this book was made). We discussed the proposal with Franklin and the cousins each time we visited Zuni.

The night before their appearance was scheduled, one of the cousins called Kathy. "I'm afraid we can't come," he said.

"Oh dear, what's wrong?" Kathy was worried that Max or Kuiceyetsa was ill.

"Well, it's Franklin," he answered. "He's not sure about the ride and getting ready and . . ." His voice trailed off. "Why don't you call Franklin?" he suggested. "He's at Grandma's."

Kathy called Kuiceyetsa's home and talked to Franklin. "I don't have very many finished pieces," he said. "A buyer came through last Friday, and I have been up day and night to get some examples made."

"I can bring some of the ones you've made us," Kathy said. When he still hesitated, Kathy told him, "The students have been looking forward to this."

Franklin said, "All right, you bring Keith's bear and your horned toad, and I'll finish up some pieces."

The classes went very well. The high school students were fascinated, and Franklin and his cousins warmed to their audiences. Toward the end of the last class, Franklin looked across the room, caught Kathy's eye and asked, "Is this what you wanted?" In that moment, it was clear that he had nearly responded in a traditional

Zuni manner that was particularly appropriate considering the attention that he was receiving because of his mother's store and as a result of his own growing reputation. He was seeking to avoid further attention. I knew that he could use the money, but he had not done the demonstration for that or even for the students' benefit. He had done it for us because it was something we wanted, and he wanted to please us.

We went to Kuiceyetsa's that night, visited with the family members who were there, and waited to interview Helen. Late in the evening Franklin came in glowing with excitement. "I just bought a used travel trailer," he announced. "They are hauling it out to the field behind my sister's place."

"Are you going to use it as a workshop?" I asked.

"Yes, and a place to live." Franklin laughed. "It's the little trailer on the prairie." Everyone laughed.

"You moving out of your mom's place?" Max asked.

"Yeah, guess so. Need a place where my rock dust won't bother anyone." Max and Kuiceyetsa agreed that the move was good.

Working with Helen during this period was not easy. Her life was filled with her parents' declining health and with the difficulties pertaining to the store; complicated legal procedures were being initi-

ated by her lawyer and the tribal lawyers. One minute she would think she was going to get her store back and be able to keep it open; by the next weekend, everything would have changed. She said that she was being followed and watched by police everywhere she went.

There were moments and even whole days that were like old times. During one of the early trips, we went to gather clay. I got Kathy's new car stuck on the side of a Zuni mud hill and was determined not to have to walk into town to get a wrecker. I had Kathy and Helen get out. I rocked the car back and forth mightily, and it broke loose. Helen said, "Boy, you sure had your jaw locked!"

Kathy said, "Yeah, but if it hadn't been for my psychic push, we would never have made it."

With her eyes dancing, Helen asked, "Oh, was that you there in my way?" We three roared with laughter as we had done so often before.

We had brought, at Helen's direction, a shovel and a bucket, which were in the trunk. I had bought a poppy seed cake when we stopped for gas; that was in the trunk, too. Helen was standing by the car. When I got out the shovel and bucket, Helen said, "Now, don't forget the blessing! Before you get clay, you've got to do a blessing. Say 'Take. Eat.' Say it."

"Take. Eat," I said.

"Thank you. It looks good," she said. She tore off a hunk of the poppy seed cake and ate it before she did her blessing and offering. We all laughed again.

We went up the hill. I saw some layered soil that looked to me like clay, but Helen said, "Not yet. It's becoming clay all right, but it will have to be here a long time yet."

We found a prehistoric dwelling in the side of a rock wall. There were ancient handprints in the mud plaster. The built-up walls were complete. I yelled down to Kathy, telling her what we had found. Then Helen and I sat down in the room and looked out through the doorway. "Sure feels nice to sit here and look out over the valley, huh?" she asked.

"Yes," I said. That day Helen found clay, and paint rock, and potsherds to use in making our pot.

On the way back from our expedition, Helen suddenly said, "We are being followed." We looked behind us and saw a police car. "Turn down here," she said. "Let's take the back way and see if they do, too." We turned, and so did the police car. It followed us all the way to Helen's house. When we turned into her driveway, it went on to the end of the road, turned around, and drove slowly past us.

Kathy was on crutches and had a giant cast that stretched from her crushed heel to her broken knee. We had reserved a motel room for handicapped guests in

Gallup. When we got back late that night, the only parking space we could find was the marked handicapped slot that was right in front of our room. We parked there, and I helped Kathy in.

When I got up the next morning, I pulled back the drape to check the weather and saw a uniformed policeman in a police car parked in the row behind our car. We packed, and I took our bags outside. The policeman was still there. I helped Kathy to the car. When the policeman saw the cast, he smiled, waved, and drove away.

On many other occasions, however, we were not able to record or photograph Helen at all. We did see Franklin on almost every trip. Once he came by with a handful of fetishes when we were interviewing Helen at Kuiceyetsa's kitchen table. He sat them on the table in front of us. One was a bright green frog. Kathy turned it around. "That's made from malachite," Franklin explained. "An old man here died from drilling on malachite without wearing a face mask."

"That dust poisons you," Helen told us. "It's very dangerous." Kathy threw a worried look at Franklin. He grinned at her.

"Don't worry," he said. "I'm not stupid. I wear a mask." He sat down by me and watched as Kathy pulled the malachite frog over to face her. It was the size of her thumb and yet full of details, including in-set turquoise eyes and the enlarged throat of a croaking bullfrog.

"Take him home with you," Franklin told her.

"Be sure and sign your name on him first," Helen said. Franklin took a sewing machine needle from the basket on the china cabinet and scratched letters on the bottom of the frog's feet before he gave it back to Kathy.

When we got home, we saw that he had put "Z" on one back foot and "NM" on the other. Franklin had lived the Zuni ideal in art and interpersonal relationships; he had not argued with Helen, but instead of putting his personal initials on the piece as she would have done, he scratched "Z" and "NM" for Zuni, New Mexico, thus proclaiming himself a *Zuni* artist rather than an individual one.

Meanwhile, Helen's world was crumbling around her. She felt that she was under attack by witches because her restaurant and store had been too successful and had brought her too much contact with outsiders, and her accounts of the witches' attacks became more vivid and frightening with every visit. At the same time, her longstanding attraction to mysticism was growing and becoming ever more important to her. She began receiving messages from a group of ancestors she called "the grandpas." They came to her in a vision and told her that she had been chosen by

them and that she could perform divinations, deliver messages from the dead, bless objects and people, and heal. The first time Kathy was able to travel without her cast after the accident, Helen told us that spirits had come to her and made her a healer.

Kuiceyetsa said, "Some people have said that Helen can't be a medicine woman because she hasn't joined the group and been trained by them, but she's not a medicine woman, she is a healer. When she was born, that midwife held her up high in her two hands and dedicated her to God, and I knew she would be something special."

Helen said, "The grandpas told me that I am going to have a special mission to white people because they don't have anyone to help them." She told us she had "worked on" her clan sister and her family and on an Anglo friend of theirs. She "worked on" Kathy's injured foot physically and psychically—gently massaging it and running her hand lightly above it—for five hours. The severe swelling went down dramatically during the treatment. Kathy changed to a sports shoe she had not been able to wear since the wreck and wore it home. However, the swelling was back the next morning.

At first, Helen used a crystal on a chain for divination. She held it and asked questions of the grandpas. They answered her by the swinging of the crystal. After her family medicine man told her to put her crystals away, the grandpas began answering her questions directly in voices only she could hear. The questions she asked ranged from "Have I made over a thousand pots?" to "Is my brother witching Dad?" It became more and more difficult to separate what she knew firsthand or remembered from what the grandpas told her.

Helen also became more involved with the traditional home rituals of Zuni, praying, meditating, and feeding the spirits of the dead by burning food; she developed idiosyncratic beliefs and practices during this period. She spent long days in prayer and long evenings feeding the dead, and she received direct messages from a series of Spirit Helpers who told her that the planets were out of alignment and that she was needed to help restore balance to the universe.

Helen's sister accepted her view of the universe and became her helper. At one point during a visit, Helen waited in the car and directed her sister and me in the gathering of sage and cedar for a burnt offering to the grandpas, so I became a helper, too.

The grandpas also gave Helen the power to do past life readings, she said. She told me about our past lives, including one in which she and I had been Cajun brother and sister; one in prehistory when she had been married to my son, and she

and Kathy—then her sister—lived in the cave dwellings which Fewkes would explore; and one in which I had been a Blackfoot Indian in what is now Montana and died young when my band was wiped out in a raid. There were others, too.

She told me, "We are all old souls. You have lived twelve previous lives. You have reached the point you don't have to come back anymore. But you died young in all of your lives before this one. Kathy didn't want to come back this time. You talked her into it because you had been promised you would live a long life this time. You figured you would get to do the things that you hadn't before. We would have a long time together. Things would be complete. That's how you talked her into it."

These stories, each inventive and unique, shared two elements: Kathy, Helen, and I were together in various combinations, and my life was always incomplete.

Kathy and I found ourselves spending increasing amounts of time with Franklin, Max, and Kuiceyetsa while we waited for Helen to do her prayers or make her offerings, and often we had to leave without being able to photograph her. Talking it over, we realized that in the past Helen had arranged her time with us to fit our Anglo-American sense of order but seemed less able to do so now. We agreed that we needed to follow the Zuni day more closely to maximize our information gathering. We had heard about the Zuni day from a Navajo man we knew who was married to a Zuni and lived at her home. He said, "The Zunis have got their days all backwards." He said that just when he was ready for bed, people would start gathering at his wife's house, and "they'd bring out all this food, they'd put movies or cartoons in the VCR for the kids, and they'd start talking. This went on till the wee small hours." He said that one morning when he had gotten up early and was out chopping wood while everyone else was asleep, he had heard an axe across the village and, running to the sound, had found "another old Navajo man."

He was right about the Zuni day, of course, and we joined the gatherings, watched the movies on the VCR, partook of the food and the talk. But often even at midnight Helen was not able to work on the book as planned.

During one visit, however, we went with Helen and Kuiceyetsa to see the Santo Niño of Zuni, a statue of the Christ Child that may date from the establishment of the Spanish mission in 1629 and is now housed in an old Zuni adobe home. We were interviewing Helen about taking Daisy Hooee's pottery class, and she mentioned the Santo Niño. She stopped and said, "Have you ever been there?"

"No," we said.

"I thought I had taken you," she said.

"No," Kathy said, "we always meant to go, but we never did."

"Let's go," Helen said.

And so we went—an old, frail Zuni woman and her daughter, a white woman on crutches and her husband. I drove over to the Santo house. Helen and I helped Kuiceyetsa and Kathy in.

Sitting there, I felt Zuni time. I heard Kuiceyetsa and one of the women who takes care of the Santo talking quietly to each other in Zuni. I heard the crackling of the fire. I saw the statue. Thousands of pilgrims from many places and times had sat and would sit in this room. We each went up to the statue in its mirrored case and knelt before it. When we got back to Max and Kuiceyetsa's house, Helen told us that the Santo had spoken directly to her in her head as the grandpas did.

As time passed, it came to seem that Helen was probably going to lose the store. She was convinced that she was being destroyed by witches. She was constantly worn out and frantic to find a way to save her father's dream. The store and the witches and the grandpas consumed her. We spent many more long Zuni nights with Max and Kuiceyetsa waiting for Helen while she toiled outside burning offerings of food for the grandpas and then came in after midnight too exhausted to talk.

One night, however, she told us about her night of terror. She was confined to her couch, she said, and wave after wave of witches swept toward her and over her and tried to take her soul. The grandpas saved her by destroying the witches with bursts of psychic energy. She said that there were small children and babies in the hoard. She told us that she said to the grandpas, "Oh, no, not the babies. Don't hurt the babies." She said, "The grandpas told me, 'Why are you worried about them? They are just as powerful as you are, and they want to hurt you. Don't worry about them. They must be destroyed, too.'"

Another night, when Max sat telling stories, turned out to be the last time we would see him alive. It was late, and he was tired. Helen was elsewhere. Max spoke in a low, harsh whisper, his voice almost gone. I sat on the floor by his chair so I could understand him. He told one of my favorites of his stories about the time he used to drive a truck for "old man Hubble" at the Hubble Trading Post in Ganado, Arizona— now a national monument and tourist attraction. He said, "There was a big Navajo family that lived at the Gap in northern Arizona. The old grandpa was a friend of Hubble's. He always kept his best wool when he sheared and sold it to old man Hubble for rug making. One year Hubble sent me out to pick up the wool."

He paused and then continued, "They invited me into their hogan. It was made out of giant ponderosa logs and was a good sixty feet across, and there were these great big old rugs covering the walls. The old grandma was roasting mutton ribs over

the fire and cooking fry bread. She invited me to eat with them. We had ribs and fry bread and coffee. Those ribs were the best food I ever ate." After his story, I usually told him about how I had once had mutton ribs roasted over a fire by an old Navajo grandma, and that I agreed with him about how good they were.

He paused when he had finished his story. "Your turn. We've done this before, haven't we?"

"Yes, we have," I said. "And that's part of what I like about it. But you don't need to entertain me."

"No," he said, "we don't need to talk." We sat together in a comfortable silence.

Twenty-five days later, in January of 1996, Kathy and I attended his wake. Helen and her sisters were in command, and their brothers were clearly unhappy about it. She had picked the place and planned the service, her authority being that her dad had given her instructions—some, she said, before he died and some from the spirit world afterward. She told everyone that he had requested a "plain pine coffin," and his grandsons had built it for him. She said that he had asked to be buried wearing a new business suit, white shirt, and tie, and she bought them and dressed him.

When we arrived, Helen collapsed into my arms. Kathy wrapped her arms around us both. It was our customary greeting and parting. We three clung together in silent

sorrow for an eternity. "She is my sister," I thought. "We have always been here," I thought. "It's going to be all right."

It wasn't.

It was a long night. For a time, Kathy and I sat silently with others in the huge room—built for just this purpose—in the adobe house where Max's body lay in state. Several times during the night, I walked out to the giant bonfires on the edges of Max's property where, at Helen's direction, the young men of his wife's clan were patrolling the area with loaded deer rifles and shotguns, guarding against witches.

Franklin was there. We sat in the living room where food was being served and talked with him, with Max's other grandchildren and daughters, and with various friends. People were constantly coming and going. There was much eating, coffee drinking, and sharing of reminiscences. Max, quite naturally, was the major topic of conversation, and I discovered that Kathy and I were the only people there—perhaps the only people left alive—who had called him Max. He was "Dad" or "Grandpa" to many; Kuiceyetsa called him "mister" or "him."

Early in the night, Helen took us into Max's bedroom so we could talk. She told us that he had been witched to death by all of his sons—her brothers—working at it together. She said that she had told him while he was dying in the hospital that his

64

sons were killing him. At first, she said, he had refused to believe it, though at the last he had accepted it and quit arguing with her. She saw our incredulity and said she knew it was hard for us to understand, but that it was true, and that the witches would try to kill her mother next. Helen said that the witches had been successful against her and that she had been indicted in connection with what had happened at the store.

At another point during the night, Helen fed Max's departed spirit, burning meat stripped from roasted mutton ribs in one of the fires. When dawn finally began to arrive, there was a burst of activity as the clan cousins rushed around to open windows and doors in houses and cars so that Max's spirit wouldn't be trapped.

During the final part of the wake, Kathy and I were standing in the laundry center by the open back door, when someone came in and shut it. I opened it again to the cold Zuni wind.

There was a military procession to the family cemetery and a veteran's service by an American Legion Post—including a twenty-one-gun salute—and a Baptist graveside service. At the last, as Helen said her dad had requested, a CD of a bagpipe band playing "Amazing Grace" echoed across Zuni.

After the graveside service, we went back to the house and said goodbye to Franklin and his sisters, to the clan sister, and to Helen and her sisters. Kuiceyetsa was seated in her familiar place in the living room. I bent down, took her hand, and spoke to her.

As we were riding home, I asked, "What did you say to Kuiceyetsa?"

"I told her I loved her," Kathy replied.

"So did I," I said.

The Final Chapter

After a few weeks had gone by and we weren't able to contact Helen or Kuiceyetsa, Kathy called Helen's clan sister. She said that Helen and her sister had taken Max's truck and run away from Zuni a few days after their father's funeral, and that Kuiceyetsa had gone to live with Helen's brother. She also said that the last time she had seen Max alive, he had looked at her, shaken his head, and said, "I feel so sorry for all of you."

Five months later, in May, Franklin's sister called and told us that Kuiceyetsa had died that morning and that her wake would be the next day.

When we arrived to attend the service, we found that Helen and her sister were not there and that no one knew where they were. Her brothers and their families were in charge, and they were not speaking to us. They walked away whenever they saw us. Our only interaction with any

of them was with the brother Helen had first accused of witchcraft. I saw him and thought of all that he and his brothers had suffered, of how much his father and mother had loved him, and of how we had enjoyed his wit and charm and intelligence on many occasions. Tears spurted out of my eyes. He saw me. He nodded, and we shook hands.

We sat by Kuiceyetsa's body, which was laid out in Helen's brother's house, for a short time, and we ate portions of the meal served. But we did not stay all night at her wake as we had at Max's. We no longer belonged. We drove to a motel in Gallup and returned the next morning in time for the end of the service.

We were not at Zuni during the terrible time between Max's wake and the day Kuiceyetsa died. When we came for Kuiceyetsa's services, we talked to Franklin and his sisters, to Helen's clan sister, and to a number of other people. Eleven different people who had been closely involved in what had happened told us eleven different stories or, perhaps more accurately, eleven different versions of the same story:

"Helen and her sister took all of Max's and Kuiceyetsa's jewelry and Indian blankets and fetishes and pottery of value to Phoenix and sold them."

"They gouged out their brothers' eyes in their parents' photograph collection."

"Helen and her sister burned or smashed their parents' stuff and trashed their house."

"In their last days at Zuni, they said, 'Mom and our grandchildren—even the babies—have been initiated as witches and are trying to hurt us.'"

"Helen had said that she was thinking about leaving Zuni and had promised that she would take Franklin with her so they could start a new life. She didn't tell him she was leaving."

"'The witches put something in the water that makes our skins itch,' Helen and her sister said. They took Max's truck and went to Gallup to wash their clothes. They never returned. They probably never will."

"They called people in Zuni over the next few days as they drove away from Zuni—'in ever-widening circles to confuse the witches,' they said. They went to the home of another sister who lived far away. They stayed with her for a while. The truck was repossessed. Then they disappeared from her apartment, too."

"Helen called from somewhere and said, 'I will return exactly one year after Dad's death and raise him from the dead, and everything will be all right. Tell Franklin to keep reading his Bible.'"

"Before she died, Kuiceyetsa made a tape recording describing exactly what she wanted for her service. She planned a very traditional Zuni burial for herself. She asked that she be dressed in traditional

Zuni clothing and not have a public grave-side service. She did not mention boom box bagpipes [a recent Anglo-American tradition Helen had arranged for her father's service]."

"Most of Helen's friends and family think she took advantage of them and that her accusations of witchcraft, her stories of her psychic powers and Spirit Helpers, and her messages from the dead were cruel hoaxes."

"There has been talk about Helen in the village. The people say *she* is a witch."

As we began the trip home from Kuiceyetsa's wake, we saw Franklin walking along the side of the road. We stopped and talked to him. He said, "I don't know where she is, but Mom is stressed out and needs to go for some counseling." He went on, "Another of Mom's sisters—the one that she stayed with when she left Zuni—came home for Grandma's service, but my uncles wouldn't let her go in the house where the services were held because they said she had 'given comfort and aid to the enemy.'" He talked about his continuing fetish carving, and he told us about his recently born son named Max. I reached out of the car window and patted his head as I had done when he was a child and his mother lived in the village. He squeezed my arm. We left Zuni on May 22, 1996.

Several weeks later, when Kathy and I were driving home from a Spanish-American community in the northern part of Arizona, I asked, "Why did they let us stay and attend Kuiceyetsa's service? Why didn't they treat us like Helen's sister? We, too, 'gave aid and comfort to the enemy.' Why weren't we thrown out?"

Kathy said, "Because they knew that we loved their mom and dad and knew their mom and dad loved us. And they knew we were trying to help but didn't know how."

"And because," I continued after a long pause, "they knew we would figure out that returning would be harmful to the people we visited. We can't go back."

Kathy touched my arm and said, "I know."

"It always ends this way."

Art, Time, and Family

People and art at Zuni exist within and at the service of culture. Folk art scholars have discussed and documented the interactions among art, personalities, interests, families, and culture. Culture, they have discovered, constrains and directs folk art and artists.

Cultural constraints upon folk artists and art are particularly strong at Zuni. Part of Helen's story is the story of a pot not made. The Zuni view is that creation must serve the society as a whole, that folk art is a prayer to Mother Earth, and that artists must banish bad energy and negative

thoughts from their minds or their creations will crumble. Helen could not. Also, the preference in Zuni is for art, particularly pottery, to be produced by art families, and hers was not. The context made it impossible for Helen to practice her art.

I realized later that what had happened at Zuni to Helen and Franklin had to do with art and time and family. I was thinking of Max—of his life, the stories he told, and the funny things he did. I remembered a time when we were interviewing Helen and Kuiceyetsa about pottery. Kuiceyetsa had a valuable museum-quality water jar given to her by an Acoma friend who had made it. When we paused to change the tape, Max picked up that beautiful jar, walked into the kitchen, held the jar up, and said with a little impish grin, "*I made this.*"

It was a Zuni cross-gender, cross-generational, cross-cultural, and even cross-media monist joke. When Max was a boy, men were not allowed to make pottery, and, even as recently as the mid 1920s, when Ruth Bunzel was doing research, borrowing pottery designs from other pueblos was considered an abhorrent act. In the present day, a group of children came over every week to their grandmother and grandfather's house, where there was a big-screen television with a satellite dish, so they could watch *The X-Files*, with its final credit accompanied by a child's voice saying, "I made this."

The greatest difficulty Euro-Americans and Americans, scholars and nonscholars alike, have in understanding Zuni art, time, and family, pertains to the dualism of our culture and the need to break free—even for a moment—so as to *feel* the reality of that other worldview. Zuni is a monistic culture; the ideal is to sense and experience reality as a unified whole. Anglo-American lines divide and separate. At Zuni, to erase lines and affirm oneness is divine work. Zuni ideals were evinced by Max's joke, in which many lines were blurred: the idea of a man doing what was once a woman's work, of an old man working in what is now a young man's art, of a Zuni making an Acoma pot, of a television series being invoked in connection with the pot. And it was all directed toward Anglo-Americans conducting an interview. Max's comment was the verbal equivalent of the Zuni room we visited: a multidimensional, multilayered communication bringing together many parts in a gestalt.

I realized Max's joke was among the most apt metaphors I had ever heard. To him, Acoma, Zuni, Anglo-American, male, female, pots and people new and old, television series, art, time, and family are all one. The generation of potters after his daughter's is the first to include men as well as women, and it was Max's long political career and the quality of his life and his family that made this greater monism possible—but only at a price.

I went through a mental list of the jobs Max had held—political leader, jewelry maker, truck inspection station operator, water hauler, carpenter, employee of a federal government commission, truck driver, and submarine sailor—and the magnitude of his service hit me.

Max had served in the Second World War. Anthropologist John Adair, studying the difficulties returning veterans had in being reintegrated into the Zuni world, concluded that a number were "forced" to leave the village. Max was one who left, and he lived away from Zuni for sixteen years (he had also been away from Zuni earlier, when he attended Phoenix Indian School). During the time he lived at Zuni as an adult, Max was one of the most important political leaders of the village, of the state, and of Native Americans, but he had spent years away and had had many contacts with outsiders.

Cultural constraint is an old Zuni tradition. I remembered Max's mother, too. She had been an important informant in cultural research and had worked with many of the major ethnographers in early American anthropology. She lost her teaching position in the village in the 1920s, however, when she supported archeologist Frederick Hodge, who tried to film the Shalako ceremony and, it was said, made disparaging remarks about the Santo Niño. She was not allowed to live at Zuni and had to move away for several years.

Hodge was exiled as well, of course. He and his cameraman were thrown out of the village and their equipment confiscated. He was not the first nor the last. The many expect much of the one—and of outsiders—and the many enforce their expectations. Since Hodge's time, some outsiders have been formally banished by the tribal court; others have imposed exile upon themselves.

To be a successful member of the Middle Place is to draw no attention to oneself. Like her father before her, Helen spent much of her childhood away from Zuni, and, as an adult, she attracted a good deal of attention because she was a successful potter; she is one of the third generation in her family to be exiled. Both in her art and in her business, Helen was out of time, too successful, too much her father's "son" to fit in, and so she is out of Zuni. She had too much contact with outsiders; she was too individualistic (with her incised greenware lamps and her pots and her mysticism) and too determined to find a source of income (therefore unable to bake bread and make stew for village ceremonies). She has had to pay for these idiosyncracies.

Franklin has not attracted the attention of the village as his mother did. His wants are modest. He is a father now. He is one of many new artists who are not of an art family. He loves his art, but he avoids recognition. He intends to sign his

work, but he is just too busy. His art and his attitude toward it are relatively acceptable to his culture, and he continues to live quietly at Zuni under the shadow of the double-edged sword. He worries about his mother.

Franklin and Helen are Zuni contemporary traditional artists, and Zuni contemporary traditional art is a multifaceted and multilayered unity. Experience and analysis show that the art and the artists of Zuni *must* serve the many. Contemporary traditional artists are free only to the extent that their personalities and interests fit the constraints of their cultures, factions, and markets.

The circle continues.

References

Adair, John J. 1948. *A Study of Cultural Resistance: The Veterans of WW II at Zuni Pueblo*, Ph.D. diss., University of New Mexico.

———. 1960. "A Pueblo G.I." In *In the Company of Man: Twenty Portraits of Anthropological Informants*, edited by Joseph B. Casagrande, pp. 489–505. New York: Harper Torchbooks.

Adair, John J., and Evon Z. Vogt. 1949. "Navaho and Zuni Veterans: A Study of Contrasting Modes of Cultural Change." *American Anthropologist* 51: 547–61.

Benedict, Ruth. 1934. *Patterns of Culture*. New York: Houghton Mifflin Co.

Blom, John, and Allan Hayes. 1996. *Southwestern Pottery: Anasazi to Zuni*. Flagstaff: Northland Publishing.

Bunzel, Ruth L. 1929. *The Pueblo Potter: A Study of Creative Imagination in Primitive Art*. New York: Dover Publications, Inc.

———. 1992. *Zuni Ceremonialism*. Albuquerque: University of New Mexico Press.

Crampton, C. Gregory. 1977. *The Zunis of Cibola*. Salt Lake City: University of Utah Press.

Cunningham, Keith. 1992. *American Indians' Kitchen-Table Stories: Contemporary Conversations with Cherokee, Sioux, Hopi, Osage, Navajo, Zuni, and Members of Other Nations*. Little Rock: August House.

Cushing, Frank Hamilton. 1966. *Zuni Fetishes, Second Annual Report, Bureau of Ethnology, Washington, D.C., 1883*. Las Vegas: KC Publications.

———. 1979. *Zuni: Selected Writings of Frank Hamilton Cushing*, edited by Jessie Green. Lincoln: University of Nebraska Press.

———. 1990. *Cushing at Zuni: The Correspondence and Journals of Frank Hamilton Cushing 1879–1884*, edited by Jessie Green. Albuquerque: University of New Mexico Press.

Dittert, Alfred E., Jr., and Fred Plog. 1980. *Generations in Clay: Pueblo Pottery of the American Southwest*. Flagstaff: Northland Publishing.

Finkelstein, Harold. 1994. *Zuñi Fetish Carvings*. Decatur, GA: South West Connection.

Fowler, Carol. 1977. *Daisy Nampeyo Hooee*. Minneapolis: Dillon.

Hardin, Margaret Ann. 1983. *Gifts of the Mother Earth: Ceramics in the Zuni Tradition*. Phoenix: The Heard Museum.

———. 1988. "Using Museum Collections in Ethnographic Research: A Zuni Example." In *Perspectives on Anthropological Collections from the American Southwest, Arizona State University Anthropological Papers no. 40*, 99–111. Tempe: Arizona State University.

Jones, Michael O. 1975. *The Handmade Object and Its Maker*. Berkeley: University of California Press.

Jones, Michael O., and Robert A. Georges. 1980. *People Studying People: The Human Element in Fieldwork*. Berkeley: University of California Press.

Kirk, Ruth F. 1988. "Introduction to Zuni Fetishism." *El Palacio L, nos. 6, 7, 8, 9, 10, 1943*. Reprint. Albuquerque: Avanyu Publishing.

Kramer, Barbara. 1996. *Nampeyo and Her Pottery*. Albuquerque: University of New Mexico Press.

Li An-che. 1937. "Zuñi: Some Observations and Queries." *American Anthropologist* 39: 63–76.

Martin, Charles E. 1990. "Creative Constraints in the Folk Arts of Appalachia." In *Sense of Place: American Regional Cultures*, edited by Barbara Allen and Thomas J. Schlereth, 138–52. Lexington: The University Press of Kentucky.

Mead, Margaret. 1959. *An Anthropologist at Work:*

Writings of Ruth Benedict. Boston: Houghton Mifflin.

Pandey, Triloki Nath. 1967. *Factionalism in a Southwestern Pueblo*. Ph.D. diss., University of Chicago.

———. 1972. "Anthropologists at Zuni." *Proceedings of the American Philosophical Society*, 116 (4): 321–37.

———. 1975. "'Indian Man' Among American Indians." In *Encounter and Experience: Personal Accounts of Fieldwork*, edited by Andre Béteille and T. N. Madan, 194–213. Honolulu: University Press of Hawaii.

Rodee, Marian, and James Ostler. 1986. *Zuni Pottery*. West Chester, PA: Schiffer Publishing, Ltd.

Tedlock, Dennis. 1988. "The Witches Were Saved: A Zuni Origin Story." *Journal of American Folklore* 101 (401): 312–20.

Wyckoff, Lydia. 1990. *Designs and Factions: Politics, Religion, and Ceramics on the Hopi Third Mesa*. Albuquerque: University of New Mexico Press.

Interviews

The interviews for this book—with Helen, her sister, her mother, her daughter, her son-in-law, her clan sister, and with Franklin and others at Zuni—took place during the years 1994 to 1996. In addition to the sixteen audio cassette tapes, we recorded five hours of videotape of Franklin and two other Zuni fetish carvers explaining their art to high school classes.

We have also included information from recorded interviews conducted earlier with people in this story, including Daisy Hooee, Randy Nahohai, and Rowena Him, and from informal conversations (not recorded) with many other Zuni contemporary traditional artists over an eighteen-year period.

P L A T E I
Storm on Corn Mountain,
1992.

73

P L A T E 2
Hawikuh, 1984. Partial
walls and shaped building
stones remain from 1680.

74

P L A T E 3
Zuni oven being heated
for use.

75

PLATE 4
Wall in Helen's house and
Franklin sitting on the
couch, 1984.

76

P L A T E 5
Display at Helen's store.

77

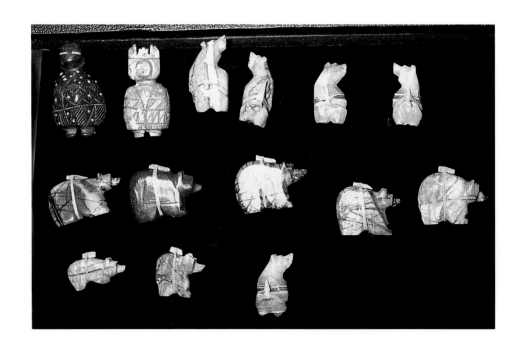

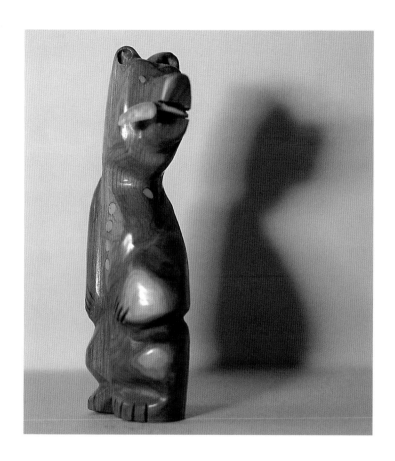

P L A T E 7
Cedar bear by Joseph R.
Quam, Jr.

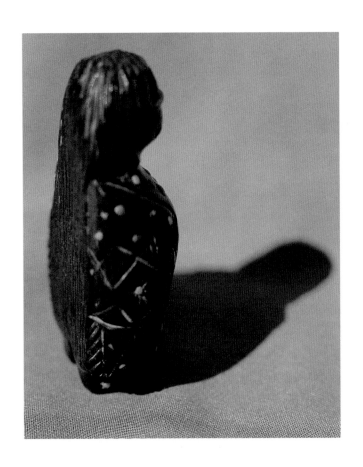

PLATE 8
Olla Maiden figure by
Joseph R. Quam, Jr.

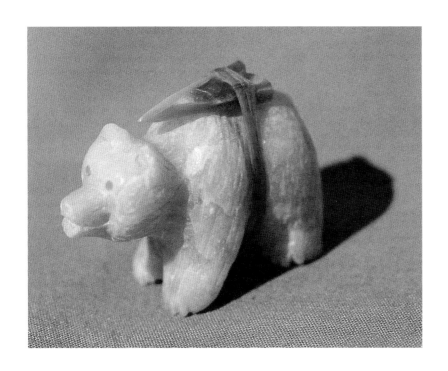

PLATE 9
Bear fetish by Scott
Garnaat.

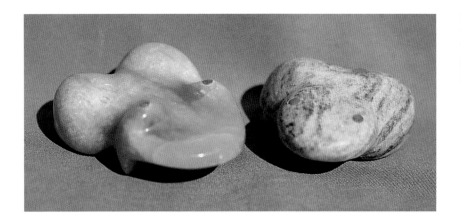

PLATE 10
Two stylized frog fetishes. These are of the same general style as the ones Rick Quam makes.

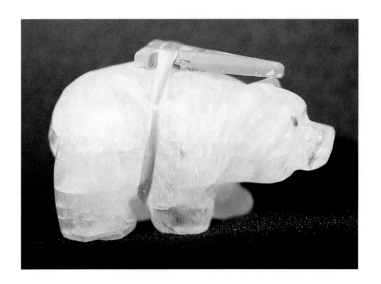

PLATE 11
Bear fetish by Franklin.

82

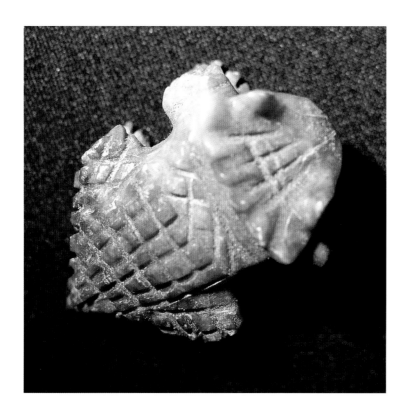

PLATE 12
Horned toad fetish by
Franklin.

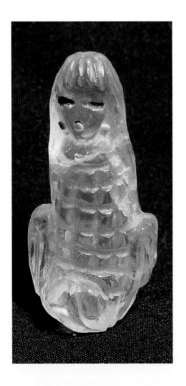

PLATE 13
Corn Maiden fetish by
Franklin.

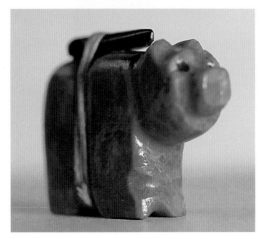

PLATE 14
Franklin's finished bear.

84

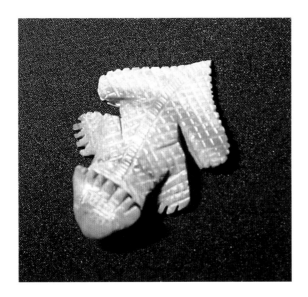

PLATE 15
Franklin's serpentine
horned toad.

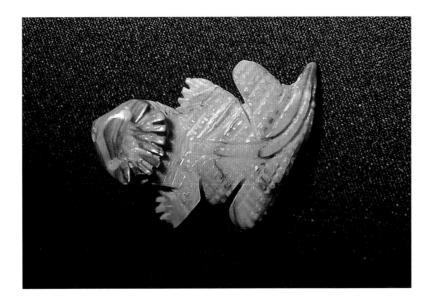

PLATE 16
Franklin's abalone
horned toad.

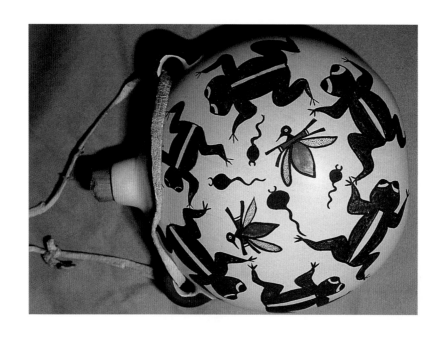

P L A T E 17
Canteen Helen made
for Max.

PLATE 18
One of the first bowls
Helen made.

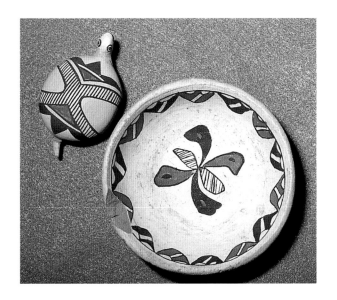

PLATE 19
A bowl and a turtle effigy
pot Helen made.

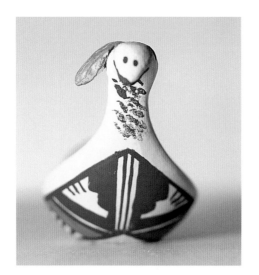

PLATE 20
Turkey effigy by Helen.

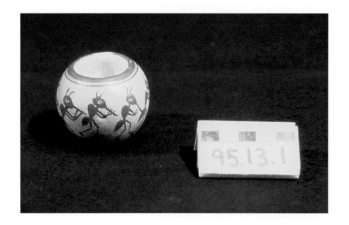

PLATE 21
Daisy Hooee ant pot.
(Artifact Number 95.13.1.
Courtesy Maxwell Museum of Anthropology.)

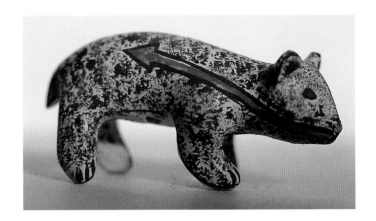

PLATE 22
Pottery bear with a
heartline Helen made
and painted.

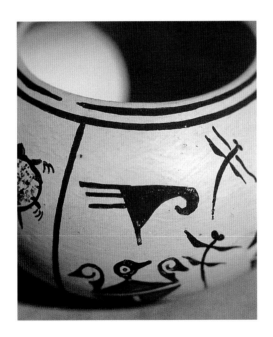

PLATE 23
Rainbird.

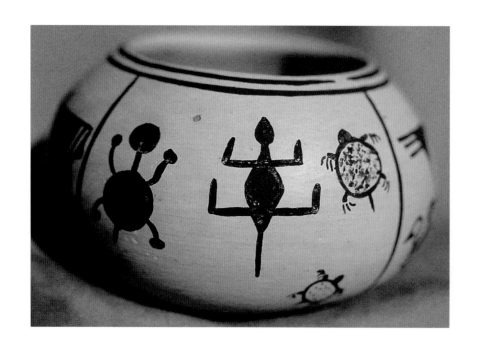

PLATE 24
Lizard and turtle.

90

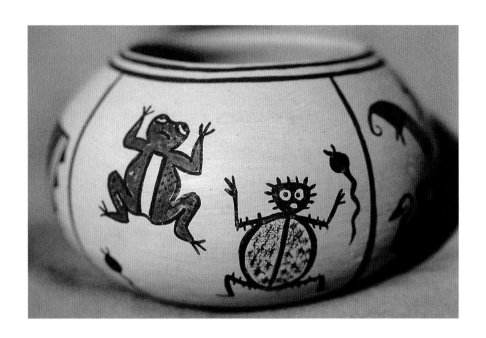

P L A T E 25
Frog and horned toad.

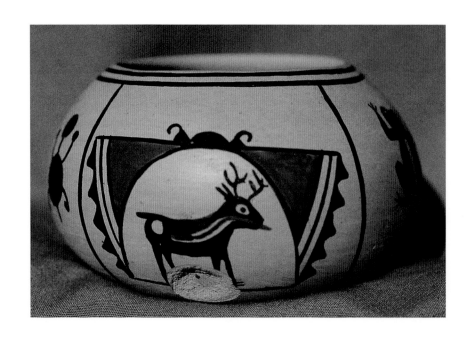

PLATE 26
Deer in his house.

92

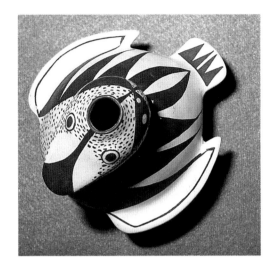

P L A T E 27
Duck effigy Helen made
for Kuiceyetsa.

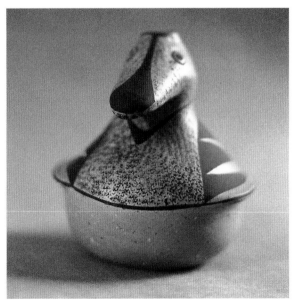

P L A T E 28
Duck effigy Helen made
for us.

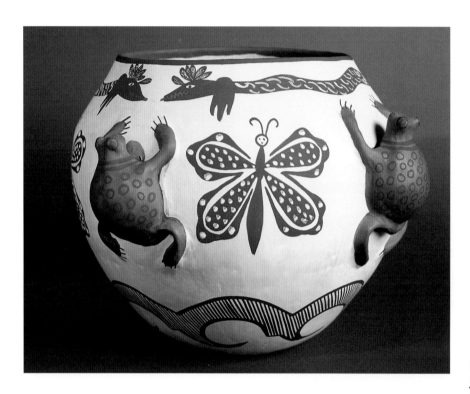

P L A T E 29
Jennie Laate pot.
(ID Number NA-SW-
ZU-A7-45. Courtesy
Heard Museum.)

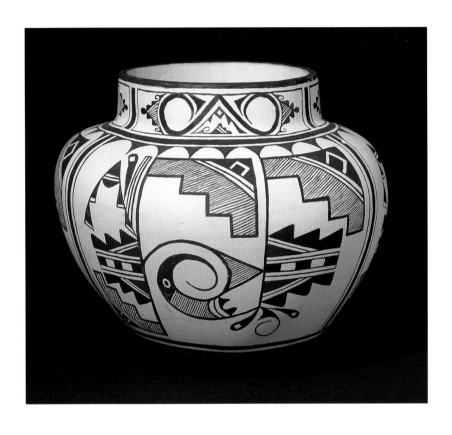

Pot by Josephine, Randy, and Milford Nahohai. This pot was a family affair. Josephine is listed as potter and her sons Randy and Milford are listed as designer and painter. (ID Number NA-SW-ZU-A7-44. Courtesy Heard Museum.)

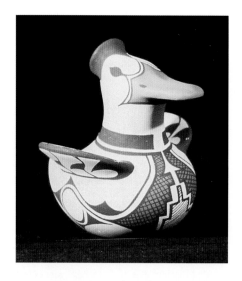

PLATE 31
Duck by Rowena Him.
(Object ID Number
87.48.1. Courtesy
Maxwell Museum of
Anthropology.)

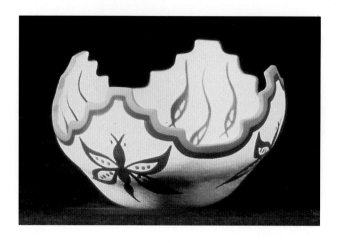

PLATE 32
Bowl by Priscilla Pey-
netsa. (Object ID Num-
ber 87.48.9. Courtesy
Maxwell Museum of
Anthropology.)